IMAGES
of America

BINGHAMTON

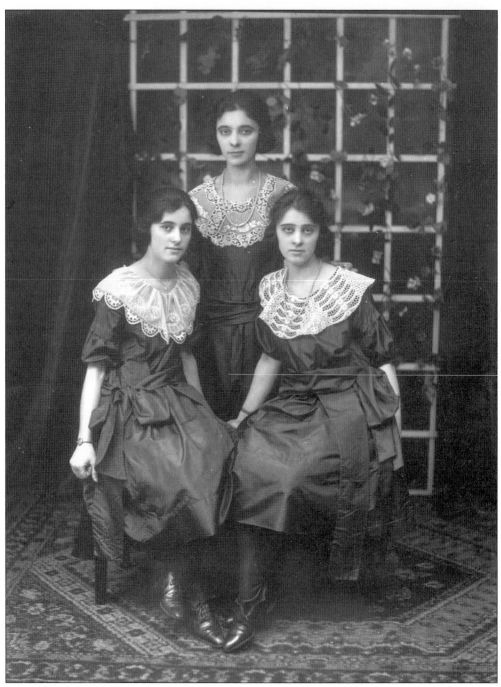

A trio of beauties in stunning lace collars pose for the camera in 1900.

IMAGES
of America

BINGHAMTON

Ed Aswad and Suzanne M. Meredith
Foreword by Rick Marsi

ARCADIA

First printed in 2001.
Reprinted in 2002.

Published by Arcadia Publishing,
an imprint of Tempus Publishing, Inc.
2A Cumberland Street
Charleston, SC 29401

Printed in Great Britain.

Library of Congress Catalog Card Number: 2001093036

For all general information contact Arcadia Publishing at:
Telephone 843-853-2070
Fax 843-853-0044
E-Mail sales@arcadiapublishing.com

For customer service and orders:
Toll-Free 1-888-313-2665

Visit us on the internet at http://www.arcadiapublishing.com

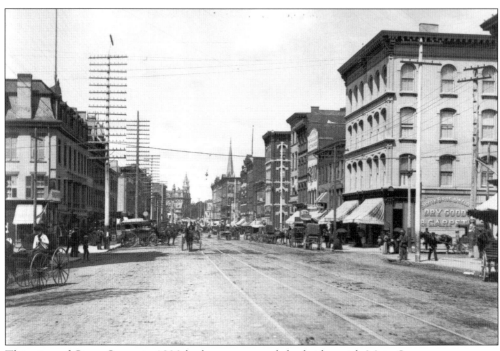

This view of Court Street in 1890 looks west toward the bridge with Main Street.

CONTENTS

ACKNOWLEDGMENTS

The following people and organizations shared their talents, information, and photographs. Without their generous assistance this volume would not have been possible.

The Amos Patterson Museum, Town of Union
Shirley Alig
Eloise Bowers
Broome County Historical Society
Charles J. Brown – Broome County deputy historian, Broome County Historical Society librarian
Broome County Public Library, Local History & Genealogy Center
Steve Contento – Ross Park executive director
Fairview Press
Morton H. Gilinsky
IBM Archives
Chipppella N. Lewis
Fred Poliziano
Gerald R. Smith – Broome County historian
Doug Snow
Pearl Webb

Special thanks to:

Richard P. Gillespie, for photographs and an introduction
Rev. Cynthia Kimler, for editorial advice
William C. Kimler, for his introduction
Rick Marsi, for providing the foreword to this volume

The major portion of the photographs included have not previously been published and are from the collection of Ed Aswad.

FOREWORD

Sometimes when I sit in a long line of traffic, I yearn for the buckboard, the stagecoach, a reliable horse. I see myself living in my hometown of Binghamton, New York, a century or more ago, buying 5¢ cigars, paying for my newspaper subscription with firewood, and quaffing Dr. Kilmer's herbal remedy when a touch of ague comes on. My house, on a street with gas lamps, is Queen Anne style—curling staircase, marble hearth—with a yard easing down to the river.

I smoke a clay pipe, down an occasional sarsaparilla, own a hound dog named Buster, and buy suspenders from my favorite peddler. In winter a horse-drawn sleigh arrives at the door with fresh milk. The store where I buy clothes sells "gentlemen's furnishings," and if Dr. Kilmer cannot help with my ague condition, I mosey on down to the local bathetorium, where a medicinal dunking awaits. Heading home, I stop in at the local sweetshop: penny candy, fresh bread, cakes, and pies.

Then a horn honks behind me. Reality check. I do not live in old Binghamton. Like it or not, I live now.

But I can go back, walk the streets, tour the past, through the pages of this wonderful book. This is a special collection, featuring a lively, informative text, plus an expertly chosen selection of photographs, many published here for the first time. Lose yourself in these pages, and you will experience horse-drawn carriages without manure, steam engines without soot, and corsets without all that pinching—the good old days sans inconvenience.

You will dream what I dream when I am sitting in traffic. Here, Buster! Make mine sarsaparilla.

—Rick Marsi

INTRODUCTION

Binghamton is an unusual city. At times it offers the sophisticated culture of a metropolis; yet, one can also feel at home with the intimacy of Small Town, USA. Even though countless hours can be spent exploring Binghamton's offerings, it does not take more than 10 minutes to drive through the heart of the city.

In this book the authors celebrate the uniqueness of Binghamton, presenting a historical portrait of the city. Ed Aswad and Sue Meredith have amassed rare photographs, postcards, and other documents that are as interesting as they are historically significant. This collection invokes curiosity, wonderment, and at times a bit of puzzlement.

A true portrayal of daily life in Binghamton over the centuries emerges. Anonymous faces and forgotten buildings echo the essence of the past. When filtered through the authors' subtle but sharp wit (developed from a lifelong residence in the area) the images become real and a fondness grows for unknown eras.

You will see a photograph of a prim and proper woman holding a parasol in one hand and a five-foot gun in the other. There is a wonderfully bizarre picture of an extremely furry sheriff. You will experience the affection residents have had for the region expressed in the songs "Bingo" and "Riverside Rag." Some comfort can be taken in the fact that even 100 years ago, people misspelled the city name, adding the dastardly "p," making it Binghampton.

The volume offers a glimpse of the uncommon aspects of an interesting and offbeat Binghamton.

—William C. Kimler V

I have been an enthusiastic collector of postcards and photographs of early Binghamton for more years than I care to admit. The experts tell us that people accumulate items of antiquity because of nostalgia for their youth or perhaps a longing for an era never experienced. As a youngster when the opportunity arose to look at a vintage photograph, my imagination attempted to visualize life in bygone Binghamton, the great and the mundane moments, each unique event remaining frozen in time for eternity. The "good old days," what a challenging and exciting time it must have been to live and work!

Antique postcards and photographs reflect our heritage as a permanent visual record of a moment in history. Photographs can tell us of the social climate of the times we study, whether it is the flapper era of the Roaring Twenties or the typical Labor Day parades that united our community. A disappearing past, buildings swathed in flag bunting for the celebration of the glorious Fourth, the picturesque trolley car vanishing down Court Street, or a view of a family going for a Sunday ride in a horse-drawn carriage, all are treasures, scenes to be cherished and shared.

Many thanks to Suzanne Meredith and Ed Aswad for publishing these gems of Binghamton's past. The collaboration of their efforts has created a "time capsule" that does more than just preserve images of faces, fashions, and factories. These photographs are intimate reminders of a lost way of life.

—Richard B. Gillespie

One
THE BEGINNING

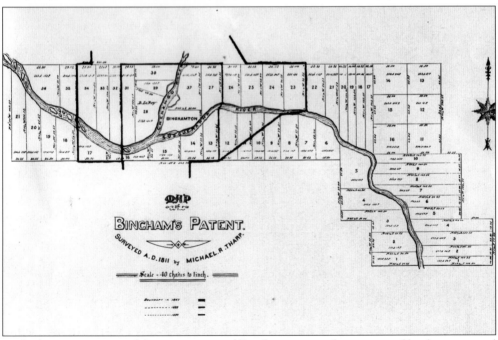

In the late 1700s, most of the present city of Binghamton stood on a tract of land once owned by William Bingham of Philadelphia. Born in 1752, William Bingham was a wealthy banker and one of the earliest diplomats in the U.S. foreign service. By combining his holdings with those of other landowners in the section, Bingham acquired a large-sized tract known as the Bingham Patent. His plan was to create an ideal settlement in the wilderness that would eventually become a center of commerce in New York State. Bingham died in 1804 without ever having seen the city that immortalized his name.

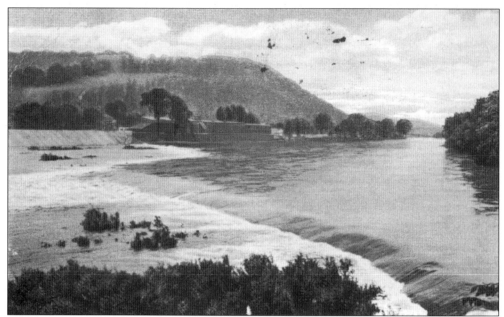

Mount Prospect towers above the river valley that holds Binghamton. Paths through the slopes and summit of the forested hill testified to human presence long after the native people had moved away. As late as the 1920s, vague trails were still visible where a park, golf course, and housing development have now laid claim.

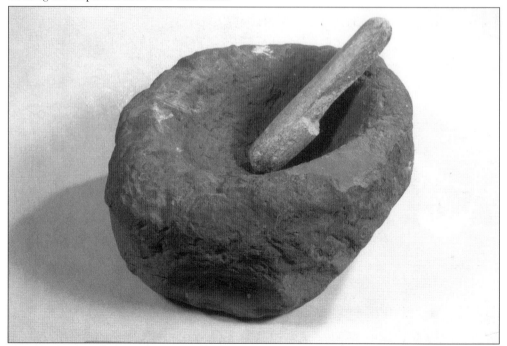

Artifacts from the Indian culture, such as pottery, arrow points, and stone tools, are still being discovered in Binghamton. This stone bowl and pestle were found on Mount Prospect. These ancient relics date from approximately 400 to 500 years ago. The bowl was chipped from a huge rock and weighs slightly more than 60 pounds.

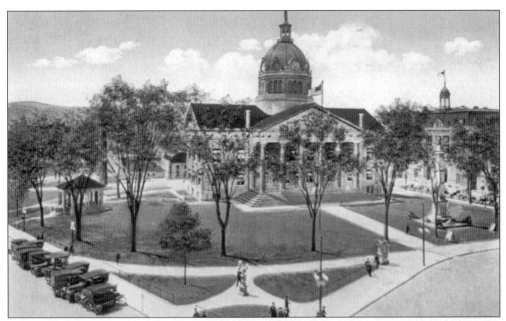

The first courthouse in Binghamton was built in 1802 and, when outgrown 1828, it was moved across the road. The second courthouse was constructed of brick in 1828. Conservative citizens also recycled this building when a new one was needed. Its second life was as the Globe Hotel, on Collier Street. The third courthouse, built in 1857, burned in 1896. The fourth and current courthouse was constructed in 1898.

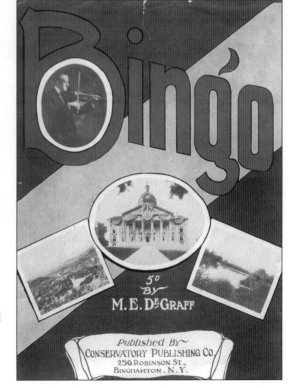

For many years Binghamton was known affectionately by residents as "Bingo." Promotional notices were printed encouraging people to settle in Binghamton, "a place where you can hit the jackpot for living conditions and opportunity." A song was written in 1920 to immortalize sentiments about Bingo, the "Parlor City, clean, fair, and grand."

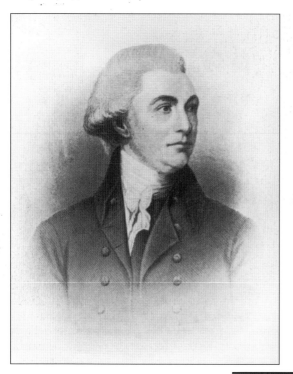

In 1790, wealthy land speculator, early American colonist, and Revolutionary War patriot William Bingham made an advantageous agreement with James Wilson and Robert Hooper. By dividing a large land patent, Bingham received the choicest location: 10,000 acres at the junction of the Susquehanna and Chenango Rivers. When his holdings increased to 15,000 acres, Bingham donated land for the courthouse and other public buildings to encourage the growth of Binghamton, then known as Chenango Point.

Anne Willing (1764–1801) was born into a family of wealth and privilege. Her marriage to William Bingham at the age of 16 was considered a good match. As a beautiful and accomplished woman, her social life included all the prominent citizens of the era, both in the United States and in Europe. Several of the first presidents of America were among her admirers. It is probable that George Washington himself recommended her likeness be put on some of the first U.S. silver coins minted. Anne Bingham's image was eventually on all the silver coins, including the Liberty dollar.

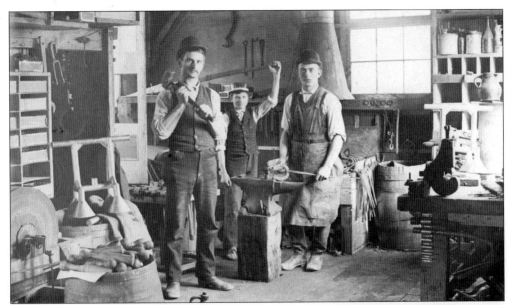

Every early community needed a blacksmith. In 1788, Nathaniel Delano was working at this trade from his small log cabin with a bark roof. In 1810, a Mr. Atwell was operating a bellows and a fiddle in the city. During the day he worked at his blacksmith shop. At night he taught dancing school accompanying students' steps with his sprightly violin tunes. The picture shows a blacksmith in the 1890s.

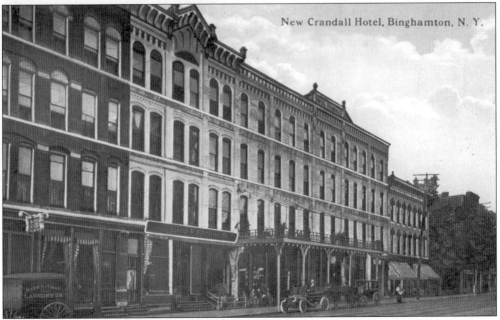

New Crandall Hotel, Binghamton, N. Y.

Albert Way built Way's Hotel at 129 Court Street in the early 1830s. His son-in-law took over the operation and, *c.* 1890, built a new brick four-story inn called the Crandall House. An 1885 publication gave it a fairly mediocre recommendation, saying, "as a resort it is a proper sort of house fit for people from the country." The rates were $2 a day, or $1.25 for theatrical people.

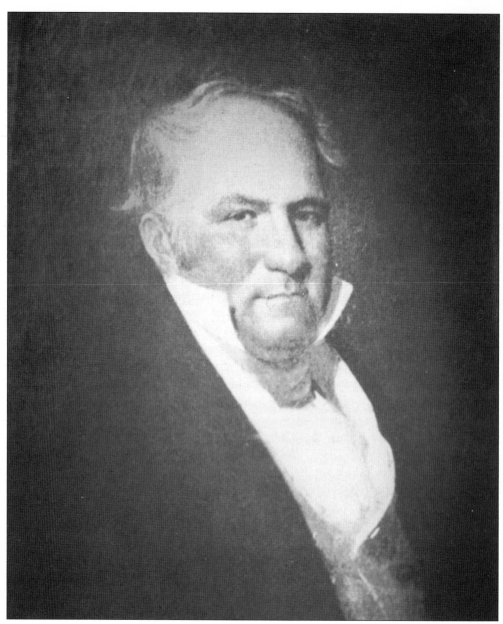

Joshua Whitney worked as land agent for William Bingham until his untimely death in 1798. Whitney's 18-year-old son, Joshua, was appointed as agent on July 4, 1800. He received a grant from Bingham authorizing him to plan a community in which trades, industries, and arts would flourish. He laid out streets in the chosen location at the junction of rivers, cleared the area of "troublesome and obstinate squatters," and sold parcels for $24 per acre. Whitney helped found Christ Church and served on the vestry, purchasing a pew for each member of his family. As the years went on, he became quite corpulent, weighing over 300 pounds. On becoming too large to fit comfortably into the standard church pew, he requested permission to design an area to accommodate his girth. The church politely declined the changes. Whitney served two terms in the New York State legislature, held the office of treasurer for the county of Broome, and maintained the position of Bingham's agent for 40 years.

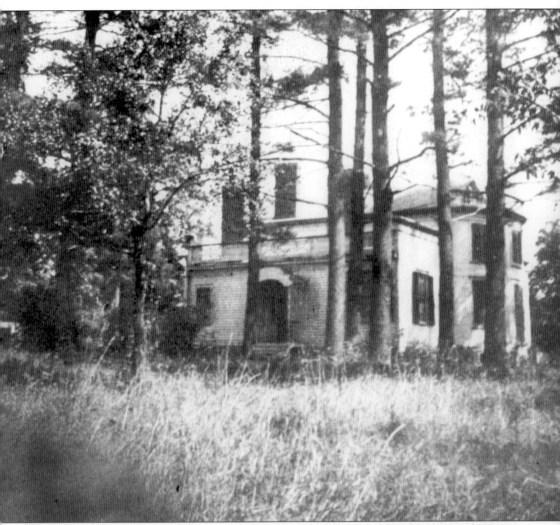

Joshua Whitney built a large home in 1806 near Court and Robinson Streets. Constructed close to the banks of the Brandywine Creek, the home cost the exorbitant sum of $4,000. Whitney was the first person to bring "Negro slaves into Binghamton" to work as servants in his new mansion. His land extended toward the river on the south, and through a swampy area to the north. Always looking for ways to expand Binghamton products he was the first person to successfully raise cranberry crops in the low ground of bogs and marshes between the Whitney garden and the creek. The home was often referred to as the Cranberry Mansion. As years passed, Whitney died, the area deteriorated and, in 1915, the home was demolished. The cranberry bog became a dump that attracted rats the local newspaper claimed were the size of horses. In 1927, the swampland was filled and became part of the Brandywine Highway.

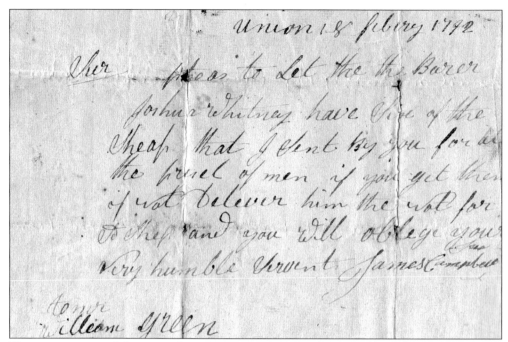

This is a rare original document from 1792, requesting the "barer" Joshua Whitney be given six "sheap that I sent by you for a friend of min . . . if you get them, if not deliver him the not [note] for the shep and you will oblige your very humble servent."

In the 1800s, each municipality elected a "pathmaster" to oversee roads, tolls, and canals. Tollbooths, every 10 miles, charged 4¢ for a horse and rider, and 8¢ for a score of sheep or hogs. A letter of 1847 states, "I am going on the packet boat like from Binghamton. The fare is only fifty cents." This photograph is the Chenango canal bridge at Court Street. After the canal was filled, it became State Street.

George Park, born in 1789, was a lawyer who moved to Binghamton in 1810. As the attorney for Joshua Whitney, Park was very prominent in city development. His abiding interest was in preserving local history by collecting maps, manuscripts, and artifacts. Also a talented artist, he recorded views of Binghamton in detailed sketches. This is his drawing done from recollections of Court Street in 1810. At the death of "Squire" Park in 1876, his entire collection of history was dispersed.

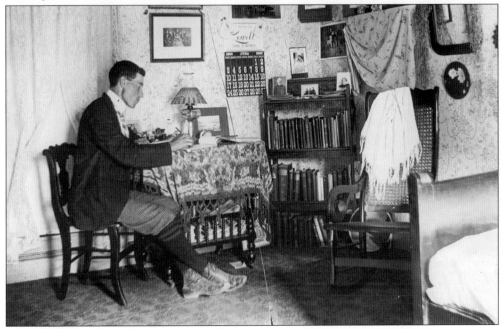

The young man is a student at the Lowell School of business in the year 1900. The room is obviously that of a local scholar. Perhaps he is the author of the letter to the editor on page 30 of this book.

Dated 1860, this document is from George Park to a livery, requesting care of horses and wagons. A note on the reverse asks that special attention be given to the two straps of bells, as they are "important."

White House, apl, 7, 1860

N. Mathewson

Sir,

I have sent word to the R. R. agent to give you the care of an Iron cutter & Harness, I presume you have recd them — I will also send you two Straps of Bells — and perhaps some Horses wagons &c, I may send the Horses wagons &c, across the country, to your place

Yours &c

Geo. B. Park

P.S. I am the same man that you kept a House for, awhile some time ago

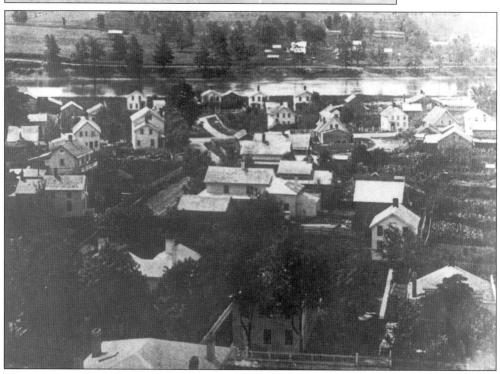

This photograph was taken from the roof of the old jailhouse, looking across to the Susquehanna River in the 1860s. At this time, as Binghamton was being developed, Ruben Harrison made an unusual discovery in the backyard of his home on Susquehanna Street. Mastodon bones were uncovered, much to the amazement of the entire village.

Daniel S. Dickinson was born in 1800. He came to Binghamton in 1831 to practice law and, in 1834, became the first president of the village of Binghamton. Dickinson tended to be an old-style gentleman: swallowtail coat, cravat, deep-ruffled shirt, always ready to engage in repartee. In 1836, he was elected New York State senator and, in 1842, lieutenant governor of New York. In 1852, he declined a nomination for president of the United States and, in 1862, became attorney general. He was "devoted to his home and family, and temperate in all habits." The family home, known as the Orchard, was located on the west bank of the Chenango River. Dickinson maintained a reputation as a man of unfaltering courage, perseverance, and honor. Dickinson was often referred to as the Noble Roman of Broome County. His obituary in 1866 read, "he was magnificently endowed, tho he was but 5 feet 9 inches tall . . . gone to the maker, pure, the most loyal and incorruptible statesman America has ever known."

The Universalist Society of Binghamton, organized in 1835, held services in the courthouse. In 1844, the society built a "plain white structure" on Court House Square, approximately at the location of the current bandstand. A local carpenter wrote to his son with many of the daily details of construction: "1844—The Universalist Society is a going to commence building a meeting house soon and have purchased a lot in a pleasant situation for 375 dollars but a few rods east of the academy and about the same distance south east of the courthouse. This lot is where a house was burnt some years ago in the spring that belonged to John Smith. The meeting house is to be 55 feet long and 38 feet wide and to contain 55 slips and a steeple. All work is done by the day and I aim to get $1 dollar a day. Mr. Ogden is to boss the work and calculates to commence when materials is brought in." This is the Church of the Messiah, the second Universalist church, built across the street from the original site.

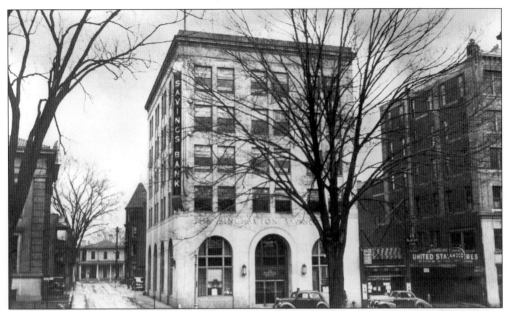

The early Universalist church dissolved *c.* 1860, and the building was thereafter destroyed by fire. In 1890, a site was purchased across the street from the original parcel for a new meetinghouse. The Church of the Messiah was built on the corner of Exchange and Congdon (then Exchange Place), where it remained until purchased in 1930, when larger offices for the Binghamton Savings Bank were constructed on the same property.

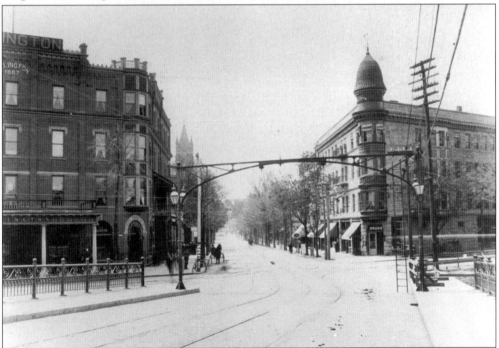

This view of Chenango Street is from the railroad viaduct, looking toward Court House Square. In the building to the right, Dean's Pharmacy dispensed advice and "cures" for many years in the beginning of the 1900s.

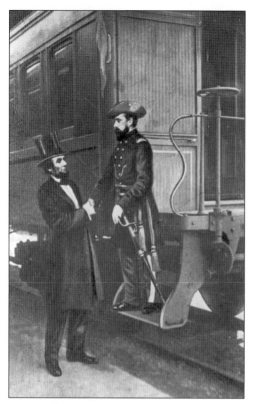

Gen. Edward Jones was acknowledged by Pres. Abraham Lincoln as having had a major influence in the winning of the Civil War. Jones moved to Binghamton in 1865 and immediately started the Jones Scale Works. The innovative advertising slogan "Jones, he pays the freight" was known throughout the country. In 1885, Jones was elected lieutenant governor of New York State. He invented a reading machine for the blind, gave the plans for it away free, and presented glasses to any child needing corrective lenses. The general became completely blind in later life. A brick mansion on Asbury Court (once known as Bates Street) is a dramatic remnant of the Jones mystique. Built in the Queen Anne style shortly after the Civil War ended, the mansion is 22 rooms of Victorian elegance. Currently, the landmark is being restored as a unique bed and breakfast establishment called the Mansion on Asbury.

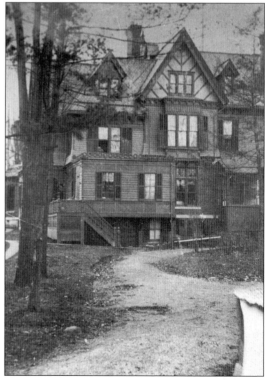

In 1872, Madam Bothe's School was located on Chenango Street, welcoming both boarding and day students. Closing exercises for that year were held at the nearby Academy of Music. Riveting recitations in French were followed with a short French comedy. This is an original program from the ceremony.

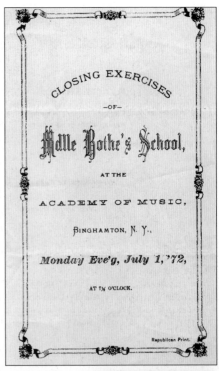

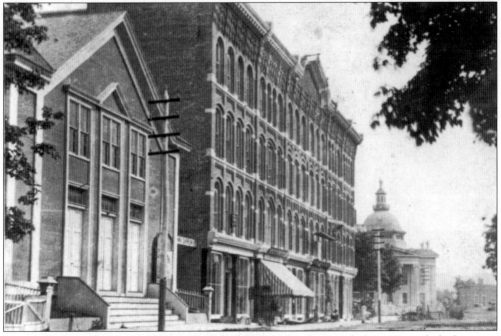

The Academy of Music, the building on the left, was the first regularly appointed playhouse in Binghamton. Located on Chenango Street, the structure was renovated in 1864 and became a famous resort for entertainment. Previously, the edifice had been a Congregational church that went bankrupt. A large steeple was removed during the reconstruction. The Academy of Music burned in 1884.

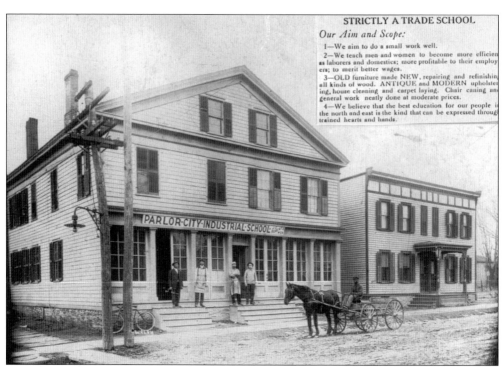

On the corner of Court and Exchange, only three buildings have occupied the site. The first was the Parlor City Industrial School. Next was the Hagaman Block, pictured below, built in 1870, demolished *c.* 1905. The current tenant of the lot, the Security Mutual Building, was then constructed. Security Mutual is an insurance company, which was organized in 1886.

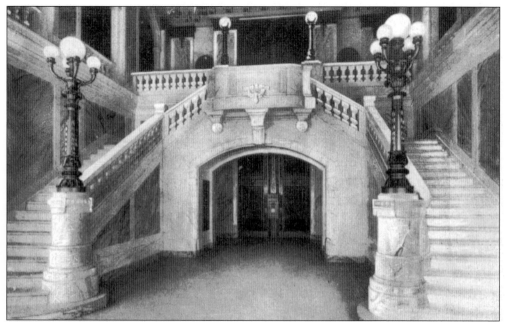

Security Mutual has a long and prominent history in Binghamton and maintains a marble entry of historical elegance. An interesting note: *c.* 1900, a "total abstinence department" was organized by L. Hoag, a man who had long been prominently identified with prohibition interests in Binghamton. The policies offered special rates to "temperance inclined individuals." This specific insurance stayed in operation until the 18th Amendment was adopted, making all alcohol imbibing illegal. The photograph below shows the rich woodwork in the executive suites.

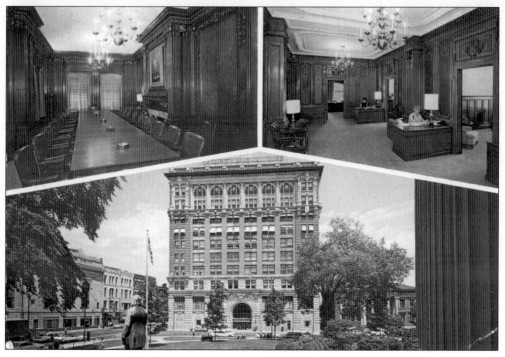

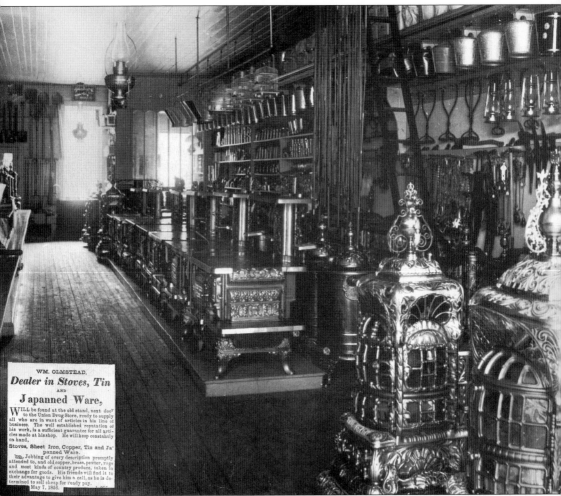

WM. OLMSTEAD.

Dealer in Stoves, Tin

AND

J apanned Ware,

WILL be found at the old stand, next door to the Union Drug Store, ready to supply all who are in want of articles in his line of business. The well established reputation of his work, is a sufficient guarantee for all articles made at his shop. He will keep constantly on hand,

Stoves, Sheet Iron, Copper, Tin and Japanned Ware.

Jobbing of every description promptly attended to, and old copper, brass, pewter, rags and most kinds of country produce, taken in exchange for goods. His friends will find it to their advantage to give him a call, as he is determined to sell cheap for ready pay.

May 7, 1856.

William Olmstead came to Broome County in 1840 and opened a business. In 1844, he wrote a letter to a prospective employee stating, "I have one hand to work for me and if I can hire another to suit me I can pay $15.00 per month, part in clothing." In 1848, he offered "a good workman in our tin shop I have been in the habit of paying nine shillings a day, but if you suit us will not quibble about wages." An 1844 letter stated, "Son, I saw Mr. Olmstead, his new stoves takes like a charm. He is hurried all the time to finish stoves for purchase. He has got another apprentice and they have as much as they can do to furnish stoves and trimmings as fast as they are made they sell. I think you would have done better to have stayed here and tin smithed for him." By 1856, the Olmsteads had moved part of their successful business to Union, advertising that most kinds of country produce would be taken in exchange for goods.

Binghamton City Hall was completed in 1897 on the site of the Firemen's Hall on Collier Street. Designed in the French Renaissance Beaux Arts style, it is a large and elegant building, which has recently been added to the National Register of Historic Places. Today, it is the Grand Royale, a singularly distinctive hotel and restaurant, part of the Sandhill Hotel Systems. The words carved above the doors read, "Let justice be done though the heavens fall. . . ."

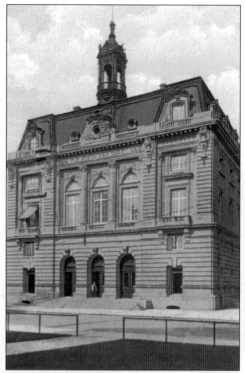

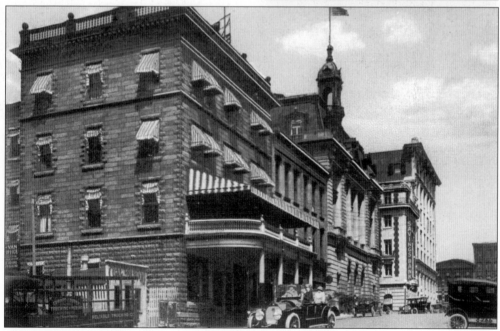

The Court Inn, built in 1915 on Collier Street, became the Broome County Humane Society and Relief Association in 1920, caring for animals and people in need. During the Depression of the 1930s, a staple of the free meals was donated by Mr. Korbel of Conklin, who produced 400 barrels of sauerkraut using cabbages grown on his farm. Spaulding Bakeries donated bread, and George F. Johnson established the operating fund.

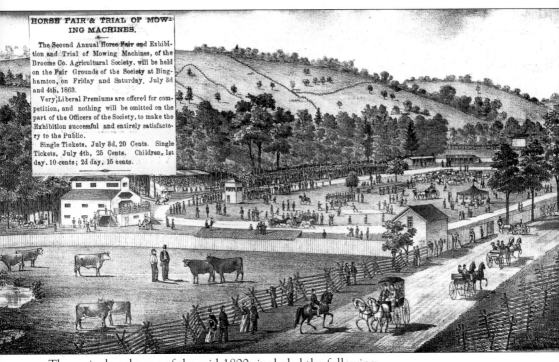

The agricultural news of the mid-1800s included the following:

The first Binghamton Agricultural fair was held in 1832.

The first farm bureau in the United States was organized in Binghamton in 1911.

1831 newspaper: "One cent reward. Run away apprentice indentured to the farming business. Whoever apprehends said boy will be entitled to the reward."

1844 letter: "Mr. Berman keeps his big hog yet and asks one shilling a piece from all who gets to see it."

1847 letter: "we are suffering for the want of rain and if the dry spell continues much longer we shall need all the provisions that we sent to relieve the Irish for sustenance of ourselves."

1850 newspaper: Two youngsters were killed by lightning. They were at work plowing with a yolk of oxen just back of Squire's barn. Though knocked down, both oxen were unhurt.

1867 local law: Any person may seize animals running at large and shall be entitled to receive from the pound keeper twenty-five cents per animal and ten cents for each goose delivered.

This engraving is from the 1876 *Broome Atlas*.

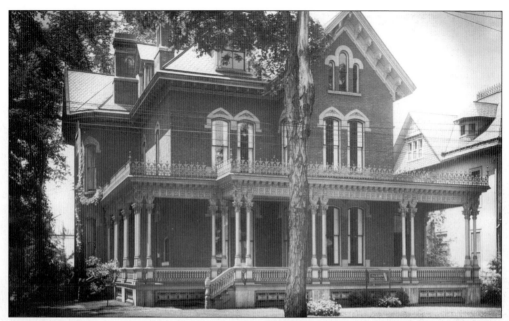

Before a permanent bridge was built over the Chenango River to connect the settlement, residents on the Court Street side of Binghamton referred to the Main Street area as "Canada," indicating the great difficulty in reaching the far side of the river. Older folks never expected Canada to amount to much because of the inaccessibility. By 1870, many of the finest mansions in Binghamton were established on Main Street, including the Stuart Wells home, designed by noted architect Isaac Perry. The elaborate ornamental ironwork is a distinctive feature of the building. It is beautifully preserved and is currently the Parson's Funeral Home.

John Stewart Wells was born in 1822. Educated locally, he learned building and contracting, eventually owning his own business and constructing many of the most important structures in Binghamton. The following was written about Wells in a volume of biographies: "In politics he was a Democrat, but had his fortunes been cast with the Republican party the highest political honors could have been awarded him."

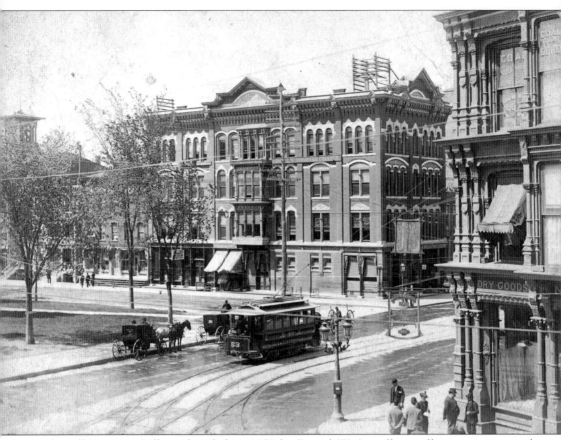

Lowell Business College, founded in 1859 by Daniel W. Lowell, is still in operation as the Ridley-Lowell Business and Technical Institute on Front Street in Binghamton. In this photograph, the school was on the upper floors of the building, on the corner of Collier and Court Street. By 1897, one of the greatest controversies in the education field was the independent women in the workforce. Local newspapers joined the debate by publishing letters to the editor on both sides of the issue.

May 1897: "Does it pay a young man to learn stenography? NO! Since the emergence of the bachelor maid into the trades and professions which were formerly filled by men wages have fallen over 80%. And what of the women whose prospects for the future are dismal as she has refused to become domesticated and is passed over for marriage. I know of no greater evil than that of parents educating their daughters for business life. It unfits her for a housewife, where a woman's sphere is the church, the cradle and the kitchen."

well **B**usiness **C**ollege,

BINGHAMTON, N. Y.

Established Thirty-Four years ago.

A thorough training given young people of both sexes in

okkeeping, . Shorthand, . Telegraphy, . Penmanship

COMMON AND HIGHER ENGLISH AND MATHEMATICS.

Business Men Furnished
Competent Office Help

ITE FOR CATALOGUE.

E. BLOOMER,

Principal and Proprietor

PHONE 650.

1894

The debate continued:

June 1897: "In regard to the letter which appeared in your May issue, I am inclined to think the man must have been a successful failure in trying to master the art of stenography and is no doubt chagrined that women should be allowed to eclipse a "lord of creation" in this field of labor, as they have in so many others. No business woman misses the opportunity of marrying simply because she works in an office. Is she less "domesticated" than the factory girl or clerk whose work takes them from home the same number of hours per day? This man has not yet gone many strides from the cradle intellectually. Because a woman meets a man on a plane of perfect equality does not make her unmaidenly."

The above advertisement appeared in a promotional booklet produced in 1894. The progressive school promised a "thorough training to young people of both sexes." The inset photograph is of Eva Hanrahan, who obtained her business degree and entered the workforce as a "typewriter."

31

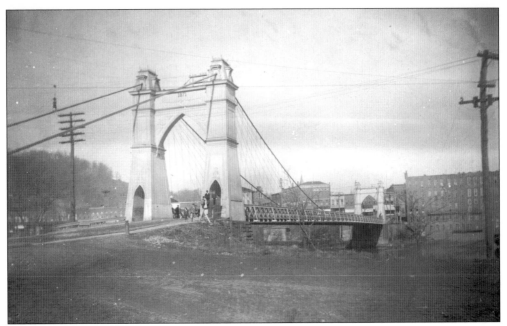

The Ferry Street Suspension bridge was erected in 1871 to connect Dickinson's Brook Meadow location, where Colonel Dwight was building elegant homes, with the rest of the city. The area thus became Dwightsville. The graceful single-span bridge with bowstring girder suspension resembled the entrance to a castle. In 1896, it was condemned. The East Clinton Street bridge is currently on this site, where a real ferry once reigned.

In the 1800s, buildings were constructed with a hitching post and mounting block in the yard. The young man and his dog are seated on a block made of wood, located conveniently near the wooden sidewalk.

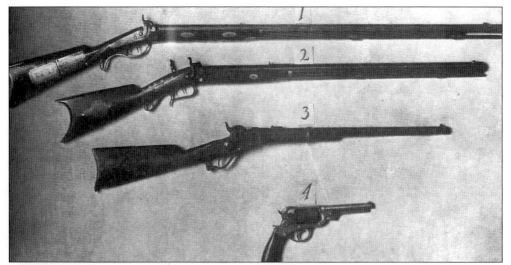

Firearms were a necessity when Binghamton was a frontier town called Chenango Point. Several gunsmiths produced high-quality rifles and handguns in the city as early as 1829. The above weapons were all manufactured locally. The rifle at the top was manufactured by Bartlett. The second one was made by Howland. The third is a Starr Carbine. The fourth is a Starr revolver.

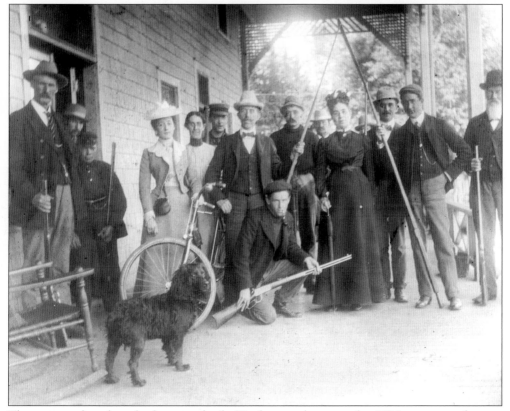

The group gathered on the front porch of a Binghamton homestead *c.* 1890 appears ready to go on a provisions party, using local firearms, of course.

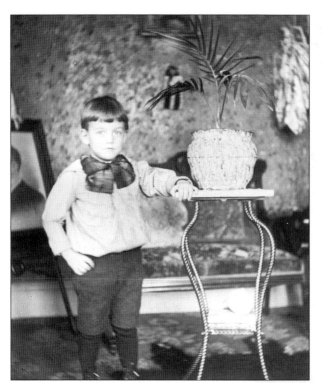

The young man, wearing high shoes, short pants, and a huge bow tie, is dressed for a formal portrait *c.* 1895 in an outfit his mother probably considered stylish. Note the fur rug beneath the plant stand, made from a local beast.

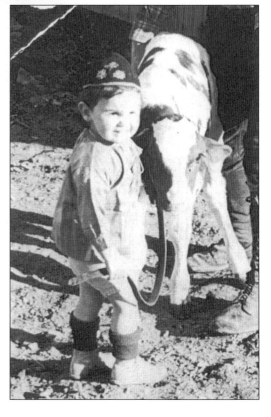

There was a small Jewish population in Binghamton as early as 1850. The numbers increased in the years just before and after World War II, when many refugees from Germany chose the Valley of Opportunity to begin a new life. Sixty of these families were farmers. Pictured is Louis Rosenberg, with his calf, in 1942.

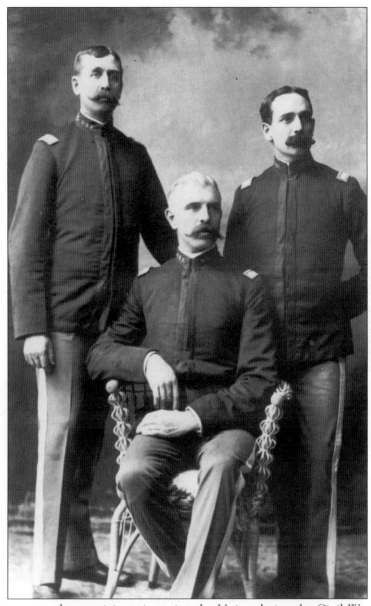

Binghamton was proud to participate in saving the Union during the Civil War. In 1861, a local lady wrote: "How do you feel about the times? Sad and terrible days have come over our beloved country, but I believe God will carry through with a great victory for freedom and the right. I am glad that some ministers has raised voices in the pulpit against these Sabbath attacks." A letter from a Binghamton man to his son in 1863 reads: "Your brother Winchester was so 'lucky' as to get a prize in Uncle Sam's lottery of $300. Which like a loyal and patriotic soldier he hurried over to the provost marshal for the benefit of the government in finishing up this rebellion which according to present appearances it will be accomplished before his time expires in being at war. This in spite of all that the copperheads can do to prevent it." Copperheads were Northerners sympathetic to the Southern cause. The photograph is of three men on their way to war, the insignia USV (United States Volunteer) clearly visible on their collars.

A fragile letter was wrapped around this tintype: "November 1848—Thanksgiving morning six o'clock. I received your letter on the 7th day. That day we WHIGS turned out and elected old 'Rough and Ready' for the next president if it be God's will. Sincerely, Annabel." The Whigs were the antislavery party, and Zachary Tyler was their candidate. Annabel was interested in politics, even though women were not allowed to vote.

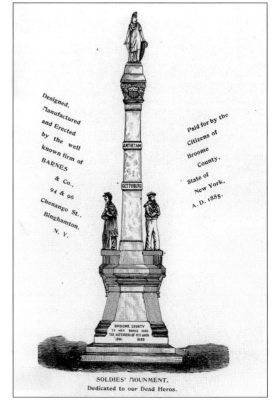

SOLDIES' MOUNMENT.
Dedicated to our Dead Heros.

As a tribute to Union servicemen, the Civil War monument was erected on Court House Square in 1888. Made of granite it is 50 feet high and includes a bronze soldier and sailor, and an 8-foot-high Lady Liberty. Four rare 10-inch seacoast mortars and carriages, made at the West Point Foundry, and pyramids of ammunition from 1841 were added at a later date.

Old Bay Tom began life as a slave. He was a local auctioneer, wrestler, and town character. In 1872, he was the first black man to be elected mayor of Binghamton . . . almost. Nominated as a joke, he won in a landslide vote over Republican opponent banker Sherman Phelps. Embarrassed election officials ordered a recount. The new results seated Phelps as mayor. (Binghamton beat the state of Florida by many years in the recount arena.)

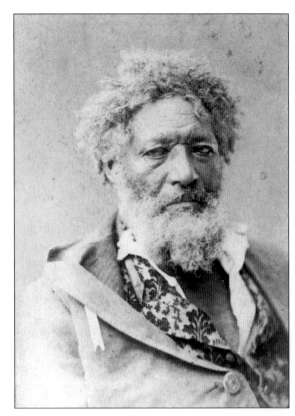

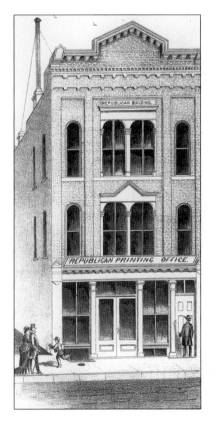

Newspapers in Binghamton were allied along party lines. The Binghamton Republican took pride in "obviously being Republican in politics and therefore prosperous and influential." An advertisement in 1863 indicates their prosperousness was not always measured in cash: "Those of our subscribers who have promised to pay their subscription in WOOD will please to bring it along. We are in need of some immediately."

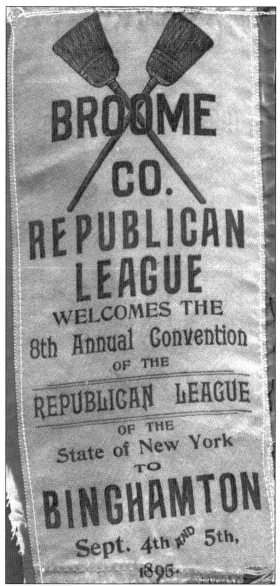

A Binghamton man's correspondence with his son covered many topics, including politics:

1844 – "Dear Son, The result of the election is as I anticipated before you left home. I knew if falsehood and misrepresentations by some, and ignorance and folly by the abolitionists were necessary to the election of Polk he would be elected. And since they have elected him I hope they will carry out all of their measures and give us annexation, and nondistribution and slavery to our hearts content."

1845 – "Father, We have passed our presidential struggle and have chosen Colonel Polk to be the man to fill the first chair. I hope he will look to the constitution and the people in the discharge of his duties."

1845 – "Dear Son, The Whigs have elected their members of assembly by a small majority in this county."

By 1895, Binghamton had become a prime setting for political meetings, as indicated by this silk ribbon from the Republican League's eighth convention.

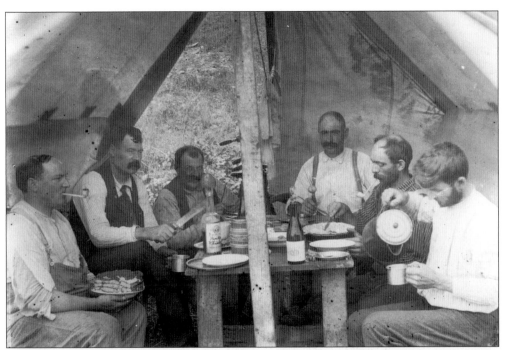

Informed sources have advised the authors that these are photographs of early-20th-century political party meetings. The menu for the group above seems to be whiskey, wine, clay pipes, and layer cake. The jesters below have included a hound dog on their board of directors.

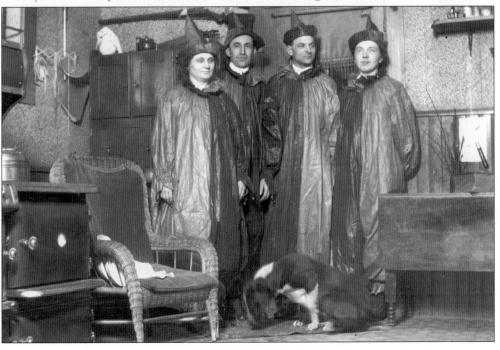

TELEPHONES

—and—

TELEPHONE SERVICE

ARE FOR THE BENEFIT OF

SUBSCRIBERS ONLY

SUGGESTION TO SUBSCRIBERS

During the busy part of the day the attendants cannot at all times instantly answer. In such cases listen attentively at your telephone, and if not answered in a reasonable time, call again.

TELEGRAMS

By arrangement with the Westen Union and Atlantic & Pacific Telegraph Companies, messengers will be sent within a radius of one-half mile from their offices to receive messages for transmission over their respective lines, without extra charge to telephone subscribers.

THE

Southern New York

Bell Telephone Co.

Binghamton Exchange

LICENSED BY THE

NATIONAL BELL TELEPHONE CO.

LIST OF SUBSCRIBERS IN CIRCUIT

Sept. 1st, 1880

A.

Anderson, Gregg & Son, Shoe Manufactory, 97 and 99 Water street................ 25
Arnott, J. H., Manager W. U. Telegraph Co, McNamara block..................... 57

B.

Brownson, D. L., Grocer, 67 Court street.... 2
Brownell, C. J. Drugs, 55 Court street...... 13
Burcey Chemical Co., South Water street... 7
Bennett, Abel & Co., Wholesale and Retail Clothing, 112 and 114 Washington street 10
Bennett, Abel, Coal, Clinton street........ 45
Bartlett Bros., Lumber, Sash &c. Collier and Hawley streets...................... 21
Binghamton Gas Works................... 19
Boss, M. E., Billiards, 81 Washington street 14
Board of Trade, Perry block.............. 53
Breeze, H. Y., office Exchange Hotel....... 48

C.

Carter & Babcock, Wholesale and Retail Hardware, 87 Washington street........ 16
Cafferty, L. M., Livery, 72 Water street 23½
Chamberlain, Floyd & Co., Wholesale Hardware, North Depot street.............36
Crocker & Ogden, Wholesale and Retail Hardware, Phelps Bank Building........... 5

D.

Darrow, H. B., Meats and Fish, 106 Court St. 50
Darrow, R. S., Hay Press, Oak street....... 32
Del. & Hudson Canal Co., Freight Office.. 43½
Del., Lack. & Western R. R., Freight Office 33

E.

Ely, H. O., M. D., 15 Jay street........... 37
Ely, S. Mills & Co., Wholesale Grocers, North Depot street........................ 29½
Ely, S. Mills, residence, Mt. Prospect...... 29
Erie Freight Depot..................... 34

G.

Gates' Passenger and Baggage Express, 11 Main street........................ 51

H.

Hirschmann Bros., Dry Goods, 15 and 17 Court street...................... 24

L.

Leader Office, 95 Water street............ 26
Lewis House......................... 27½

M.

Mosher, W. H., Grocer, 40 Court street.... 17
Meagley, R. H., Soap Manufactory, Cemetery street 31
Measgley & Blanchard, Coal, Prospect avenue 28
Marks & Clark, Wholesale Grocers, 116 and 118 Washington street.............. 9½
Moon, Geo. Q. & Co., Millers, 5 Comm'r ave. 12
Mulheron, E., M. D., 76 Court street...... 51½
Matthews & Co., Commission Dealers, McNamara block...................... 60

N.

Noyes, J. P. & Co., Comb Manufactory, Ferry street 30
Noyes, J. P., residence, 16 North street... 3½

O.

Otis Bros. Drugs, 74 Court street......... 40

P.

Patten, A. S. & Bro., Meats, 84 Washington street 13½
Police & Fire Headquarters, Firemen's Hall 22
Phelps, R. S., residence, 149 Court street.. 49½
Paige, Chaffee & Co., Insurance, Phelps Bank building 5½
Paige, C. F. and J. J. Babcock, residences, Washington and Lewis streets......... 61

S.

Smith's City Market, 89 Washington street 15
Sloan & Gifford, Drugs, 45 Court street.... 18
Schnell, J., Jr., Drugs, Main street........ 52
Stratton, J. D., Restaurant, 81 Court street 42
Susquehanna Valley Bank................ 6

W.

Whitney, C. A. & Co., Wholesale and Retail Grocers, Commercial ave.............. 55
Weed, J. B. & F. M., Tanners, 12 Susquehanna street........................ 20

Binghamton was nearly 100 years old before the telephone arrived. J.P. Noyes was one of the first businessmen to recognize the potential of the new means of communication. The Bell Telephone Company issued this telephone "book" in 1880, listing a total of 50 subscribers in Binghamton.

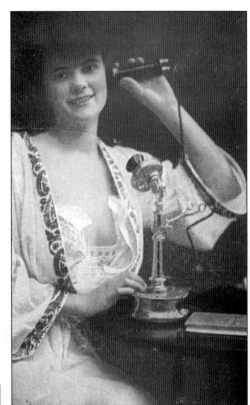

One of these photos is an advertisement for telephone service; the other is reality.

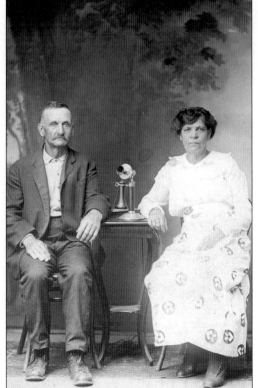

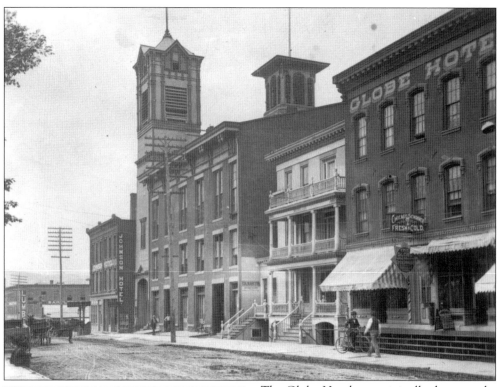

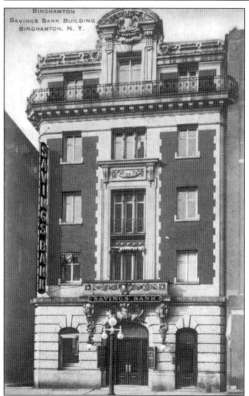

The Globe Hotel was originally the second courthouse in Binghamton, constructed in 1828. Instead of being torn down when it was outgrown in 1858, it was sold for $100 and moved. An article at the time said about the building, "it has gone to tavern keeping, seeking to get an honest livelihood, as a law abiding hotel." It is pictured here on Collier Street. The structure remained in use until it was demolished so that the Binghamton Savings Bank could be built in 1897. The bank was incorporated in 1867, opening for business with a deposit from Gen. Edward F. Jones, who opened an account with 5¢.

Two
BUSINESS AND TRANSPORTATION

The "Binghamton Song" was composed in 1925 by Lester J. Kaley for use in both the dedication ceremonies of the Memorial Bridge over the Chenango River and for the 125th anniversary of the founding of the city of Binghamton.

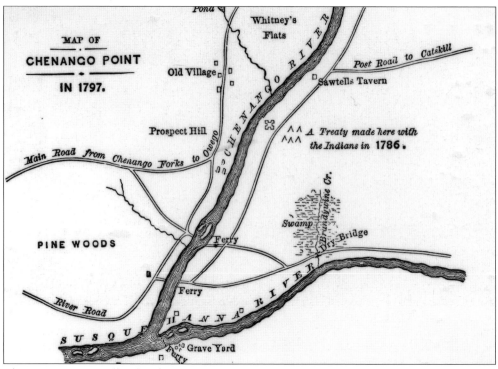

The Twin River Valley has been a choice location for settlement for centuries. Long ago aboriginal people camped along the shores that now encompass the modern city of Binghamton. The map above was published in the second edition of J.B. Wilkinson's *Annals of Binghamton.*

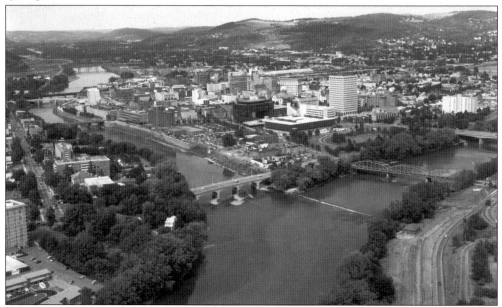

In sharp contrast to the drawing of Chenango Point, this modern-day photograph is of the same area of merging rivers 200 years later. Binghamton is a thriving city built on a solid past. The new aerial photograph is by Ed Aswad.

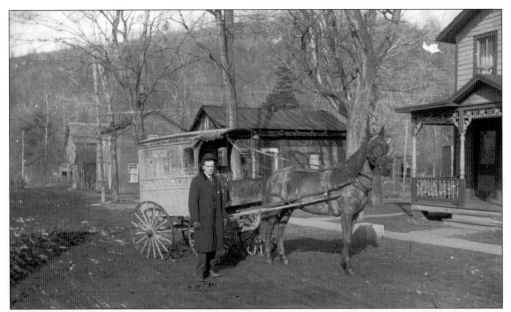

Almost everything could be brought to your door by horse-pulled carts. The Healey Tea Company pictured was one of these vendors. Many of the items delivered were packaged in fabric bags. Clothing for children was often made from sacks that had contained flour, salt, seeds, and other produce.

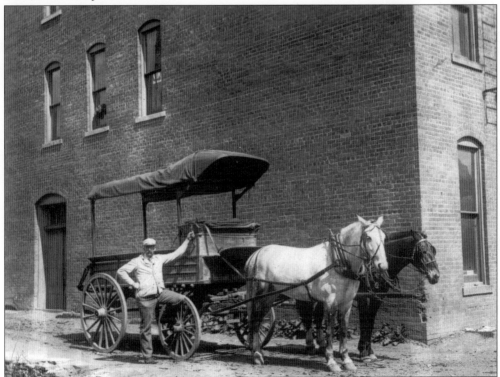

Pictured is the Wells Fargo & Company Express Wagon, with horses Speedy and Mo. In 1908, this modern delivery system was located at 160 State Street.

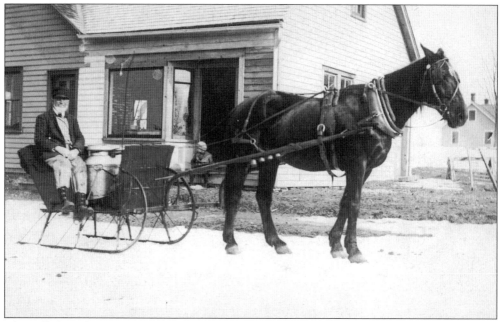

The milk from farm to store had to be delivered in summer with the horse and wagon and or in winter with the horse and sleigh. The same man is in both *c.* 1901 photographs. The Broome Farm Bureau was the chief factor in assisting dairymen in perfecting an organization for properly marketing their milk. The Dairymen's League combined many local cooperatives into one strong bargaining unit.

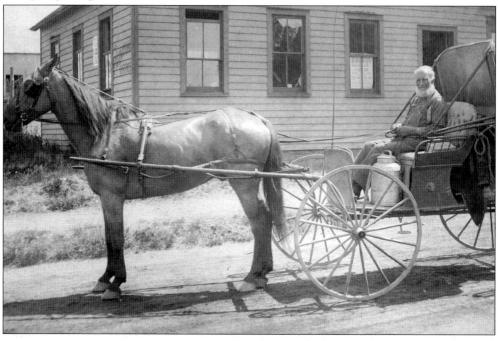

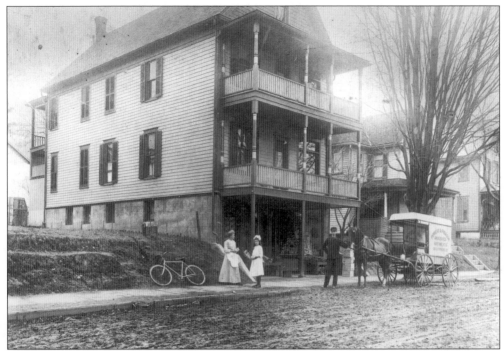

Neighborhood grocery stores rarely exist in the current century, having been gobbled up by huge supermarkets. This business, owned and operated by Mary Powers, was located at 30½ Cypress Street in 1908.

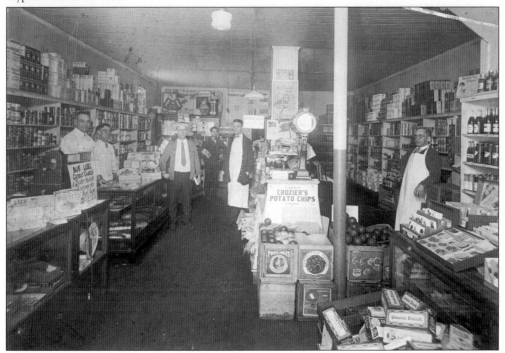

The old neighborhood store contained items for nearly every need, from garden seeds to fruit, snacks, and cigars. This interior is of a local grocery store in the early part of the 1900s.

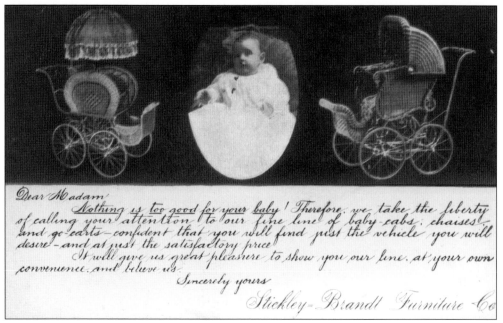

Dear Madam
 Nothing is too good for your baby! Therefore, we take the liberty of calling your attention to our fine line of baby-cabs, chaises, and go-carts—confident that you will find just the vehicle you will desire—and at just the satisfactory price.
 It will give us great pleasure to show you our line, at your own convenience, and believe us.
 Sincerely yours
 Stickley=Brandt Furniture Co

The great Gustav Stickley manufactured furniture in Binghamton for several years and then moved to Chicago. His brother stayed in Binghamton at a store on the corner of Henry and Washington Street, continuing the tradition of interesting and quality furniture.

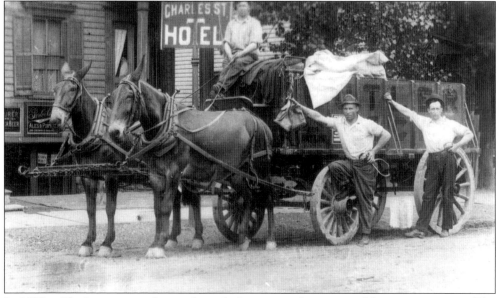

In 1895, a "flag" was put in the window of a home to indicate a need for groceries or ice. The "greenback" was worth 40¢ on the dollar. A letter to the local paper complained, "tis hard on an economical family to flag the grocer and the butcher for a week." Pictured is the Cutler Ice Company, established in 1866, whose product was gathered from a nearby pond.

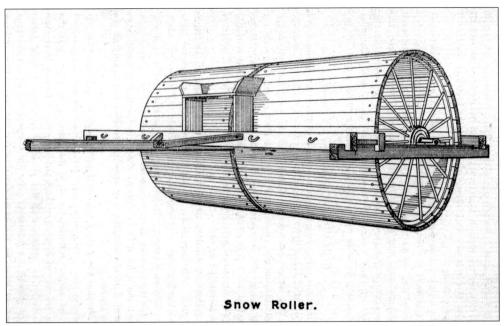

Snow Roller.

In 1906, road maintenance was beginning to be handled by municipalities. A local manual suggests using this diagram to construct an apparatus for rolling snow smooth. The photograph below is the packing machine that followed the roller, making the roadways passable for sleigh traffic. The packing device was loaded with heavy blocks of stone.

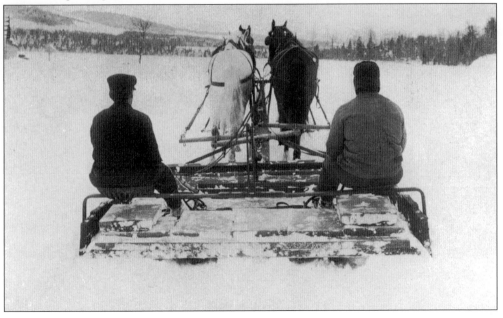

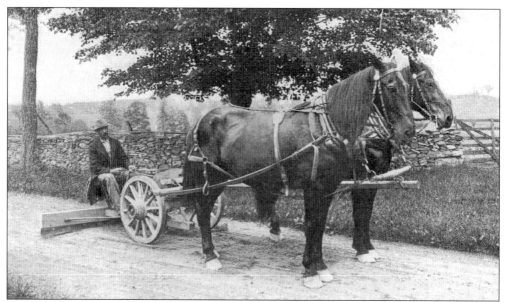

In the summer months, rut graders, similar to the one in the photograph above, were necessary for keeping roads in shape. The graders scraped and pushed, smoothing the surface. Removing unwanted "organic matter" left by horses was a primary objective. This process was followed by a steam-powered roller with a traction engine to pack the dirt hard, as shown below *c.* 1910.

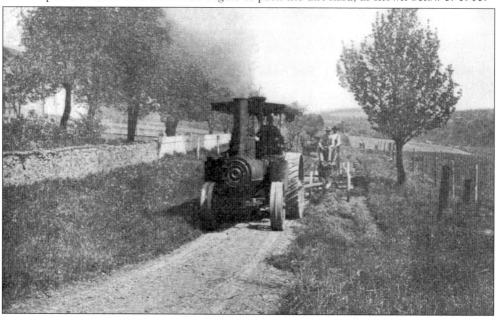

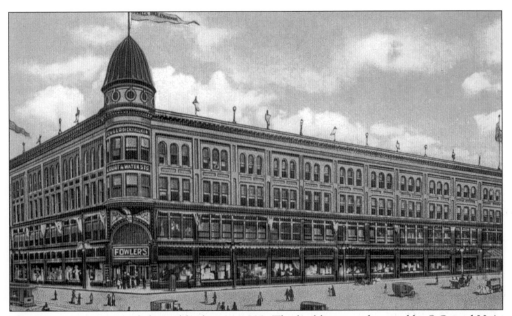

The Boston Store was a fashionable shop in 1899. The building was designed by S.O. and H.A. Lacey. It offered the convenience of a tearoom and areas for writing and resting. A full floor for music purchases, such as pianos and phonographs, was available. The store later became Fowler Dick & Walker and is now Boscov's department store.

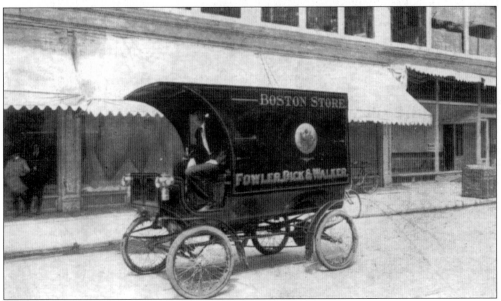

The Boston Store was the first business in the area to offer delivery service by automobile.

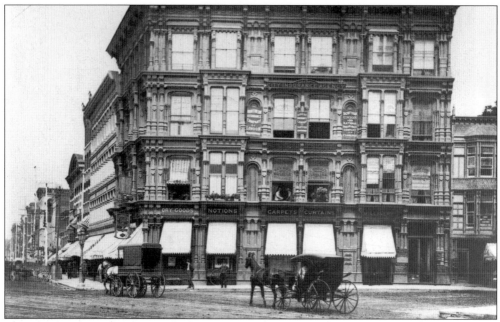

The Hills McLean & Williams department store opened for business in 1881, leasing part of the Perry Block in 1885. Two "bundle boys" and a handcart constituted the entire delivery system. In 1911, McLeans purchased the building. In the 1990s, a major motion picture was made using this cast iron building as a setting.

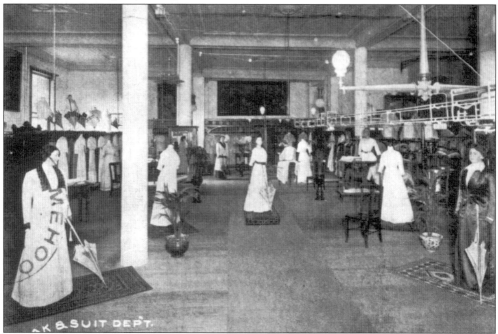

Isaac G. Perry, born in 1822, was a well-known architect in Broome County. He constructed the first and only cast iron structure in Binghamton. Perry's office and apartment were on the top floor, before it became McLeans. This is an unusual view of the cloak and suit department for women.

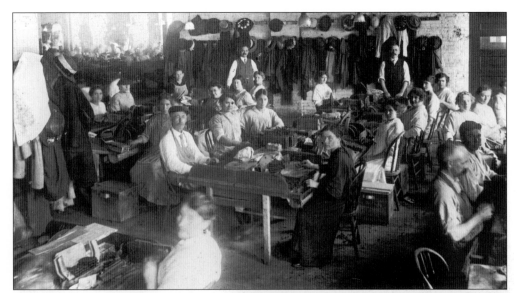

Binghamton's cigar industry began about 1870 and at its peak employed nearly 6,000 people in 70 manufacturing concerns producing 150 million cigars. To make the tip of each cigar smooth, women workers often rolled the ends in their mouths. In 1879, the *Binghamton Daily Republican* printed an editorial advising "any woman who chews tobacco deserves to be hanged for it just as much as she would for committing murder." A little drastic, but perhaps explaining why the women cigar workers enjoyed rolling the ends without being thought unladylike. Not everyone was in favor of the tobacco trade. An English tobacco buyer was referred to as the "sot weed factor." (Factor is an antiquated term for agent.) The photograph above shows a typical cigar factory workroom. The one below shows a playing card promoting the Hull Grummond Company brand of cigar.

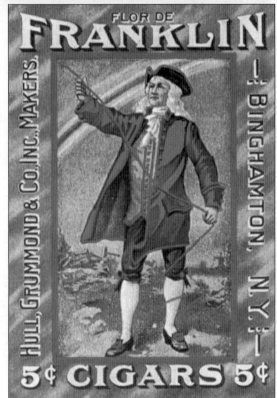

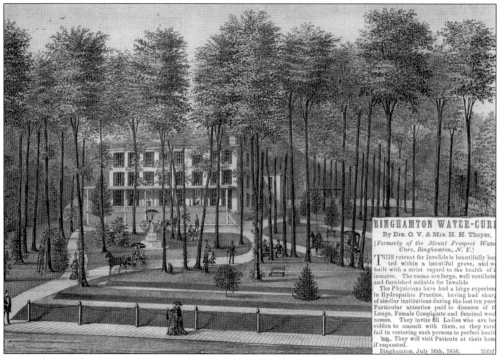

From the mid 1800s, the "Southern declivity of Mount Prospect" housed water cure establishments. According to prevailing belief, the natural springs contained nearly magical properties for healing. Hydropathic treatments and solar ray surgery were available to remove blights inside and out. The cost was $10 to $16 per week, in advance, and all patients had to provide their own linens.

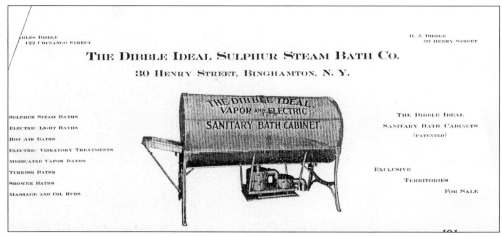

The owner of this establishment had two businesses, slightly related . . . taking care of bodies, both alive and dead. He was the owner of the Dibble Bathetorium, using healing waters in medicinal baths, and an undertaker. His "sanitary bath cabinet" almost resembles a coffin. The Dibble Bathetorium was in business from 1913 to 1923, at which time the owner pursued only the more profitable funeral trade.

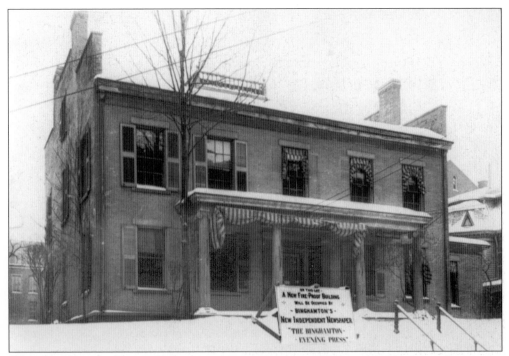

Cyrus S. Clapp, a lawyer, built this imposing home in 1841 at 19 Chenango Street. An accomplished man, he was known as an enthusiastic sportsman with gun and rod, an earnest talker and thinker, and a pessimist.

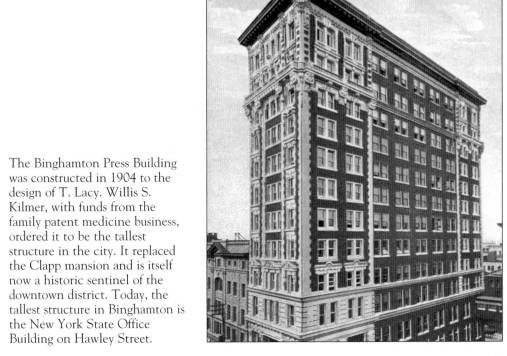

The Binghamton Press Building was constructed in 1904 to the design of T. Lacy. Willis S. Kilmer, with funds from the family patent medicine business, ordered it to be the tallest structure in the city. It replaced the Clapp mansion and is itself now a historic sentinel of the downtown district. Today, the tallest structure in Binghamton is the New York State Office Building on Hawley Street.

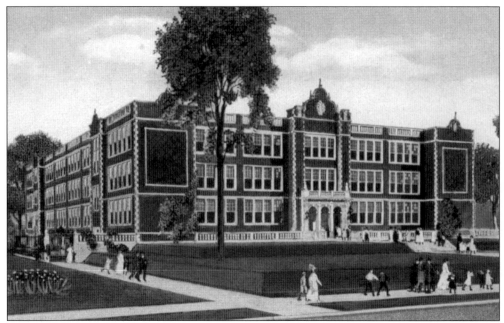

In 1913, the old Binghamton Central High School was removed and the current building erected on the same site. Many large additions to the imposing structure have changed the local landscape, enhancing the capacity for modern educational facilities . . . and metal detectors.

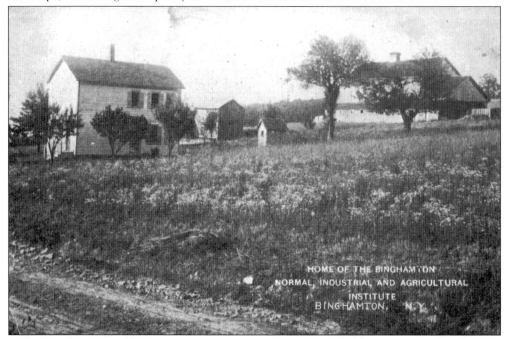

Fred C. Hazel was listed in early city directories as a mason. By 1915, he had established the Normal, Industrial, and Agricultural School of Binghamton and was listed as principal. He believed every youth should have the opportunity to learn a trade. Hazel, of African American heritage, offered instruction to people of all races. The large facility was located on Park Terrace on the south side of Binghamton.

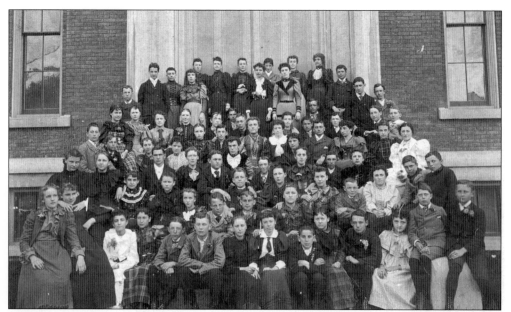

This good-sized class of students proudly graduated from the eighth grade of Binghamton High School in 1894. The attire of this group is noticeably more conservative than that of the Class of 1921 shown below.

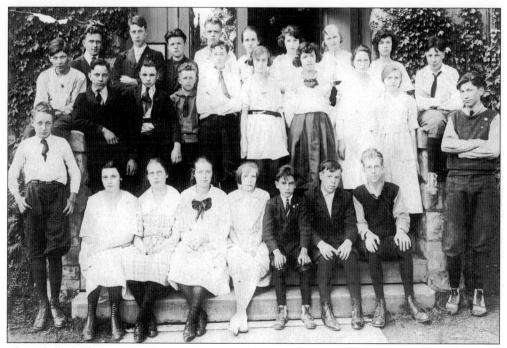

The solidly built Fairview School, constructed in 1893, was still in use in 1921, when this photograph of a graduating class was taken on the front steps.

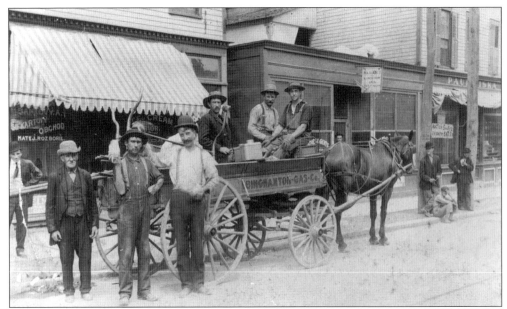

The Binghamton Gas Light Company was formed in 1853, providing gas to the city until 1887, when it combined with other corporations so it could also furnish electricity. The first electric light in Binghamton was installed in front of the Exchange Hotel in 1883. By 1885, there were all of 30 public lights stationed strategically throughout the city.

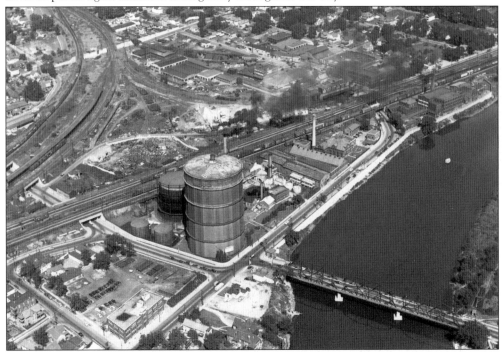

The Columbia Gas Company built a gigantic storage tank in 1926. Slightly over 200 feet tall, it sat in the gas complex near the intersection of Court Street and the Tompkins Street Bridge. It was an industrial landmark until demolished in 1969. This aerial photograph was taken by the late Bob Garvin.

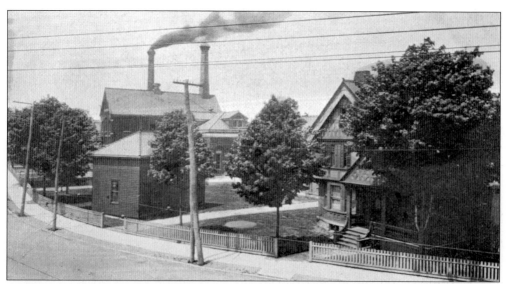

In 1857, the city legislature passed an act incorporating the Binghamton City Water Works. Until the system was completed, the community had to continue obtaining water in the primitive ways of the pioneers, using family or public wells. In the custom of early villages, communal wells were often located near the center of a road. Patterson's well, near the corner of Main and Front Streets, followed this tradition.

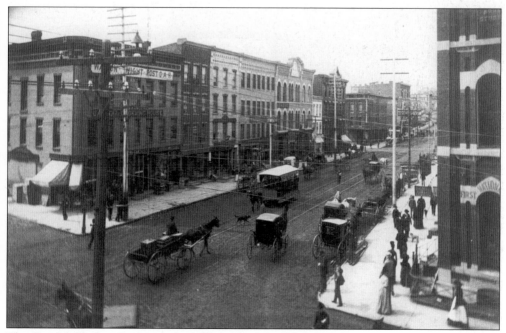

The Crystal Clothes Comapny, located on the left, did an excellent business on Court Street. However, competitor Excelsior Clothing Company operated on Collier Street and offered a distinctive service to customers: it guaranteed to "keep in repair all clothing sold by us for one year, FREE of charge."

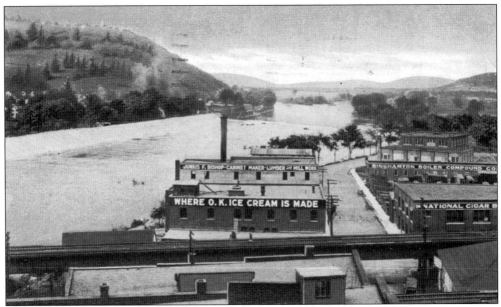

The Binghamton Ice Cream Company was organized in 1906 and located on Water Street. A quarter million gallons of ice cream per year were produced and delivered throughout a 75-mile radius. The above photograph shows the factory where the product was made, and the one below shows a typical local store where the OK brand ice cream was sold. In later years it became Sealtest Ice Cream.

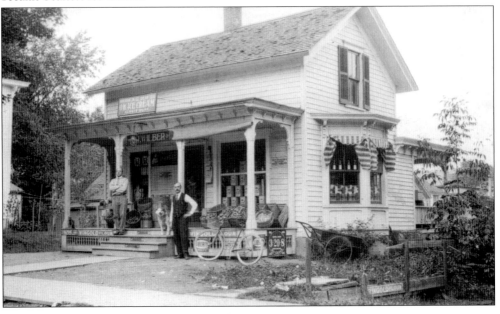

Andrew J. Horvatt
Banker

CLINTON AND WALNUT STREETS

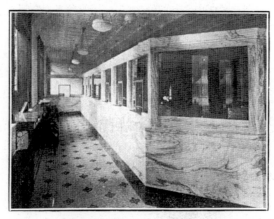

VIEW OF GENERAL BANKING OFFICE

Every Banking Convenience

Is Offered the People of Binghamton and Vicinity

GENERAL BANKING CHECKING ACCOUNTS

INTEREST DEPARTMENT
3½ Per Cent Interest Paid on Time Deposits

FOREIGN EXCHANGE

Money forwarded to any part of the world at lowest rates.

This department open evenings until 8 o'clock.

STEAMSHIP TICKETS

The largest steamship agency between New York and Buffalo. We book your passage and take care of all details.

Open evenings until 8 o'clock.

INSURANCE IN ALL FORMS
Fire, Life, Automobile, Liability

Expert Advice and Service

REAL ESTATE DEPT.

Well equipped to take care of SALES, RENTALS and the handling of all kinds of real estate.

SAFE DEPOSIT

Don't trust your bonds and valuable papers in the home. Protect them from fire and loss in our Safety Deposit vaults.

OPEN SATURDAY EVENINGS—6 TO 8:30

The State Bank of Binghamton had everything: a classy location on the corner of Clinton and Walnut Streets, real marble teller cages, and a prominent president. However, in 1930, bank president Andrew Horvatt robbed the vault of over $200,000 and disappeared. One year later he turned himself in to the police, pleading to be incarcerated anywhere but the Broome County Jail. Horvatt also operated the Orange Riding and Social Club in a very private back room of the bank, with a well stocked bar. At the height of Prohibition, Binghamton city police seized illegal liquor amounting to $166,000 in this unusual speakeasy. It was one of the largest booze operations in New York State. After the raid federal agents and gang lords descended on Binghamton for a lengthy stay. Horvatt had robbed both bank depositors and gangsters. A bootleg war was predicted to be imminent.

THE
CLIMAX-BANNER BUCKBOARD.

Shuts up like a jack-knife. Leaves no unsightly jump-irons to rattle or mar its symmetry. Rear seat as roomy as front seat. Receptacle for cushion or parcels in rear seat. Rear seat slides forward or backward on metal track and is firmly held in any position by means of a bevel gear, operated by a club handle at rear. Bevel gear is cased, which prevents cutting of parcels or cushions. The Climax-Banner buckboard is a perfect rider. Has the well and favorably-known BANNER SPRINGS which is a guarantee of its easy-riding qualities. Hangs low. Is very easy of access. Body made of genuine quartered oak. Wheels and woodwork on gear are of selected white hickory. No grain painting used. The material shows for itself. There is nothing like it on the market. The dealer who handles it need fear no competition. Write for prices.

The Binghamton Wagon Company was incorporated in 1889 and employed about 130 people in its large brick factory on Abbott Street. This full-color brochure was distributed throughout the city in 1890. The company's advertising slogans claimed that it was the "climax of carriage making," and that its product was "poetry of motion," the "mold of style," and "built for business," especially its "third position Climax-Banner buckboard," shown in the photograph below.

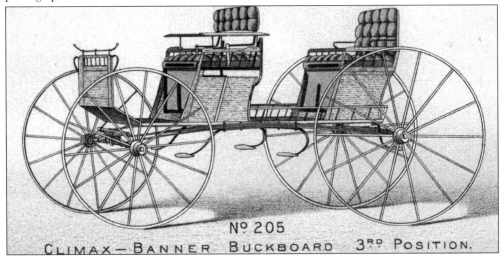

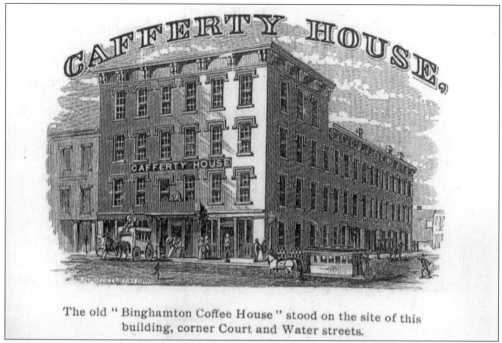

The old " Binghamton Coffee House " stood on the site of this building, corner Court and Water streets.

The Cafferty House hotel was built in 1801 on the southeast corner of Court and Water Streets. At that time it was called Lewis Keeler's Tavern. In 1895, it was operated by the Women's Christian Temperance Union, offering a cheap place for square meals and moral and social reform. It was also a refuge for fallen and poor women.

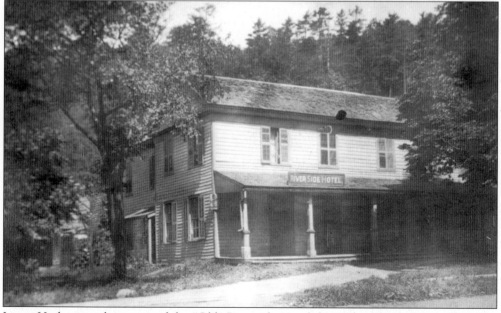

James Hazley was the owner of the "Old" Riverside Hotel, located on Front Street. He was a Civil War veteran who had a hole shot through an ear by a passing musket ball. The hotel was established in 1853. By 1925, the structure has been adapted as a motor depot, and it was later demolished. McCormick Wallpaper and Paint is now on the site.

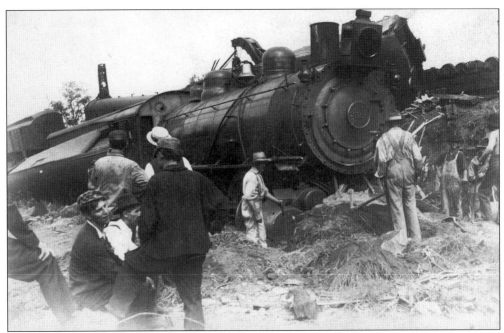

As the nature of travel progressed, so did the scope of accidents. When a train jumped the tracks, a wreck such as this one brought out the whole community to help, or watch and socialize.

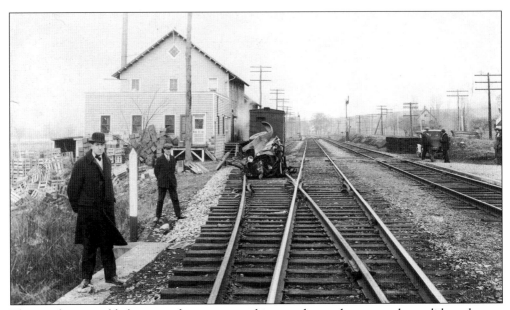

The iron horse could also cause damage to anything on the track; cows and cars did not have a chance against the tons of metal in a fast-moving steam engine, as shown by the wrecked automobile to the left of the tracks.

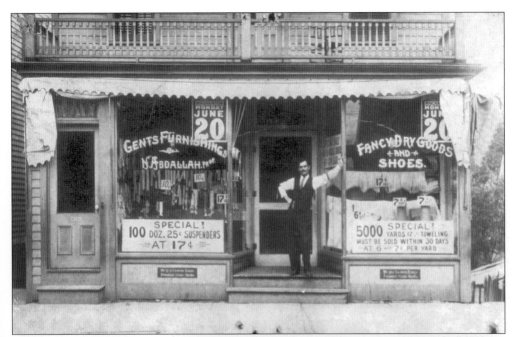

Gentlemen's furnishings could be obtained at a classic shop such as this one above that Najieb Abdallah operated on Clinton Street in 1908. Also, if you can believe what you see in the image on the right, dated 1900, ties and suspenders could be purchased from door-to-door peddlers. Both photographs were made from glass negatives, but the second one seems to have a very staged appearance.

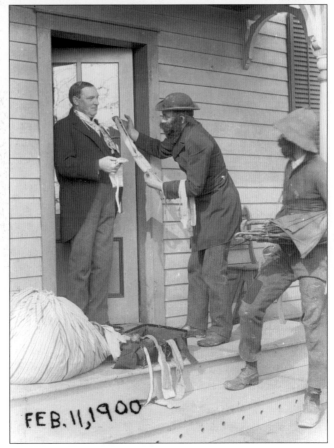

FEB. 11, 1900

The Commercial Travelers of America was organized in 1891, when there were 500,000 traveling salesmen in the country. A magnificent home and hospital on a 100-acre site on South Mountain was planned to protect and shelter unfortunate and indigent members of the association. Binghamton contributed $15,000 and the land as incentive to build. Unfortunately, it was a poor investment: the structure failed to materialize.

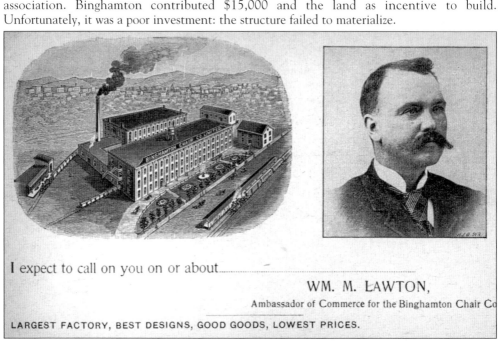

I expect to call on you on or about

WM. M. LAWTON,
Ambassador of Commerce for the Binghamton Chair Co

LARGEST FACTORY, BEST DESIGNS, GOOD GOODS, LOWEST PRICES.

The Binghamton Chair Company operated from 1883 to 1924 on Montgomery Street. William Lawton was a commercial traveler for the firm and promoted himself as an "Ambassador of Commerce." The corporation manufactured fancy and artistic rockers.

Frank Ames lived in a modest home on Main Street from 1888 until 1893. In 1894, he used the land to construct the Ames Block, a grand "temporary residence" for travelers. Mahogany-lined hallways, stained glass windows, rich wood floors, linens changed weekly, bathrooms just down the hall, and corner rooms boasting fireplaces and a sink were among the modern conveniences of the impressive facility.

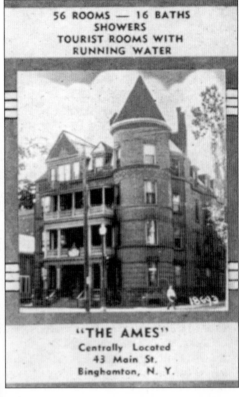

56 ROOMS — 16 BATHS
SHOWERS
TOURIST ROOMS WITH
RUNNING WATER

"THE AMES"
Centrally Located
43 Main St.
Binghamton, N. Y.

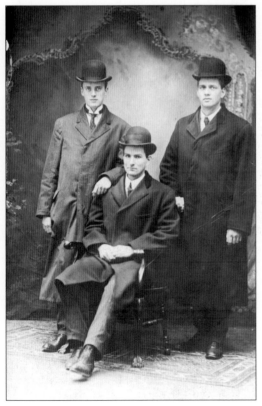

This photograph is of traveling men, called drummers or salesmen, who made good use of rooming houses such as the Ames.

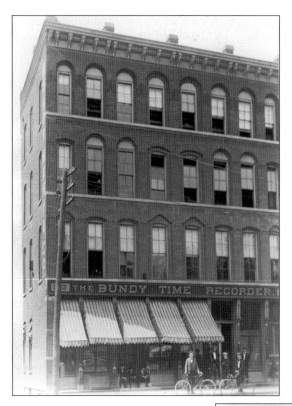

It began with Bundy of Binghamton in 1888 and developed into the computer giant IBM. In 1888, Willard Bundy, a jeweler, devised a mechanical time recorder. He and his brother Harlow Bundy opened a manufacturing company in Binghamton. In 1911, they purchased the Hollerith automatic punch card tabulating machine, developed in 1884. The machine was used to process data in the 1890 and 1900 U.S. censuses.

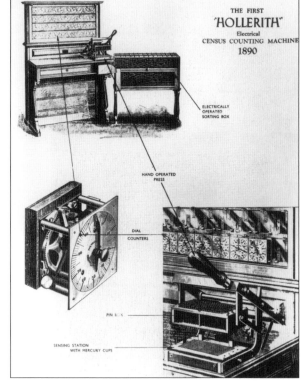

THE FIRST "HOLLERITH" Electrical CENSUS COUNTING MACHINE 1890

If the state of Florida had used one of these vintage Hollerith machines for the 2000 elections rather than their less sophisticated versions, a clear vote count might have been produced. However, some enigmatic entries for the 1890 census did present a puzzle as to how the following occupations should be tabulated: miser, crook, tramp, villain, toper, musically inclined, and Democratic stump speaker.

The future of world leadership in the computing field started with updating the Bundy Corporation to the International Time Recording Company c. 1907. After relocating to Endicott and combining with two other companies, ITR became the Computing, Tabulating and Recording Company in 1911. In 1924, Thomas Watson renamed the company International Business Machines Corporation. The calendar is a 1907 promotional tool for ITR of Binghamton.

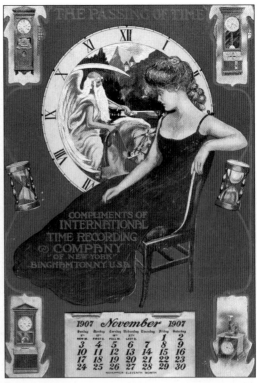

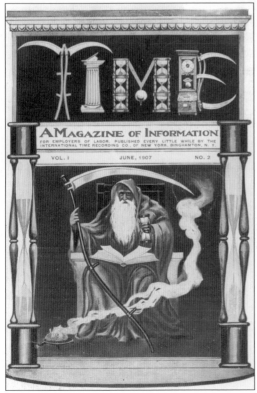

The first Bundy Company factory was part of an old gristmill on Commercial Alley in Binghamton. Four years later it moved to larger quarters on Water Street. Before the famous slogan "THINK" became synonymous with IBM, "Safeguarding the Minute" were the bywords of the corporation. Almost from the beginning, ITR produced a magazine of information for employees. This example of *Time* is dated 1907.

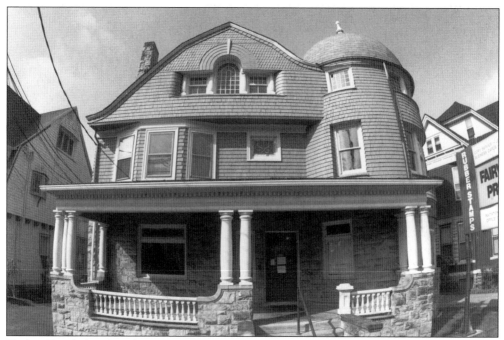

Harlow Bundy lived in this Queen Anne-style mansion on Main Street. Built in the 1880s, it showcases details common to this design—a stone porch and sections of the construction curvilinear in form. At one time the front lawn had statuary and was surrounded by a thick box hedge. The building looks much the same today even though it houses a commercial business, Fairview Press. This current photograph was taken by Ed Aswad.

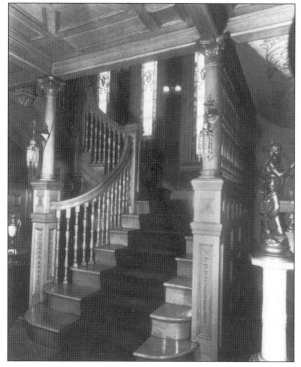

The interior of the Bundy home is shown in this early 1900 photograph. The gently curving staircase flows into an entry with delicately carved woodwork. Stained glass windows and ornate light fixtures illuminate the elegance. The Bundy era of graceful living has been preserved by creatively adapting the space for office use.

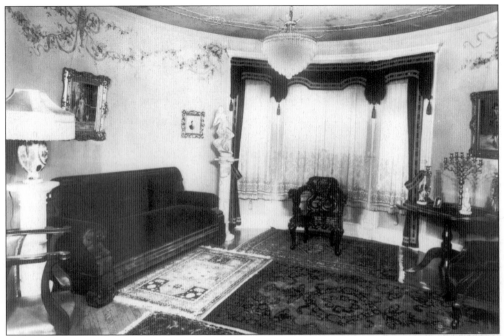

The first-floor parlor is part of the circular structure. Taste and opulence are obvious in the stenciled border and ceiling and in the crystal chandelier, large wood-trimmed furnishings, and oriental carpets.

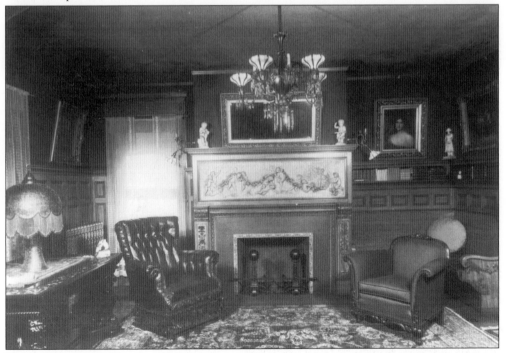

The living room, or library, of the Bundy mansion had a solid massive table, an ornate carving over the fireplace, and obviously costly light fixtures. Although the furnishings have been removed to accommodate commerce, the structure and its vintage woodwork remain intact.

Dr. S. Andral Kilmer established a patent medicine firm in 1878. His herbal remedies became known throughout the United States and Canada. The concoctions tasted good because of a large sugar content and seemed to help because the few roots and herbs were combined with 12 percent alcohol. Kilmer sold the company to his brother Jonas Kilmer, whose son Willis Sharp Kilmer built the family business into a vast empire.

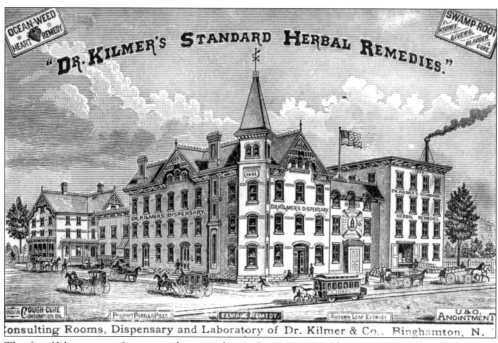

The first Kilmer manufacturing plant was located at 370–376 Chenango Street in 1879. It contained consulting rooms and a dispensary, as well as a laboratory and packaging facility. The building impressed patrons with its vast size and imposing exterior. A fire in 1899 destroyed "medicine city," which was thereafter razed.

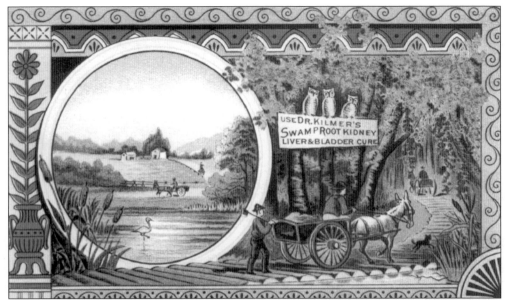

Swamp Root was the most well known of the Kilmer remedies. The brew was credited with astonishing cures for all kidney, liver, and bladder ailments. Under the direction of Willis S. Kilmer, the advertising for the company became aggressive and flamboyant, as illustrated by this colorful postcard of swamps being searched for healing roots. Kilmer died of diabetes—strangely, but not surprisingly, one of the diseases Swamp Root made claim to cure.

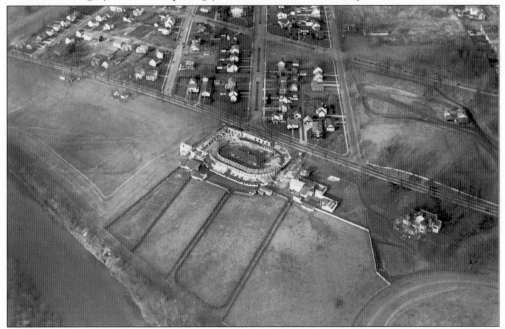

The Kilmer estate on Riverside Drive included an elaborate stable and racetrack complex, where some of the finest thoroughbred horses in the country were raised. Sun Brian Court was an attraction for tourists eager to catch a glimpse of Exterminator, the 1917 Kentucky Derby winner. During World War I, Willis Kilmer maintained a camp on the Westcott farm opposite the Kilmer holdings to train boys for work on farms that were left without help.

The Rev. Peter Lockwood came to Binghamton in 1827 as pastor of the Presbyterian church. He built the home pictured above on the corner of Chenango and Lewis Streets in 1828. After a serious illness debilitated him, he retired from church life. Upon recovery he opened a select school for boys in 1830 and lived on the estate until 1879.

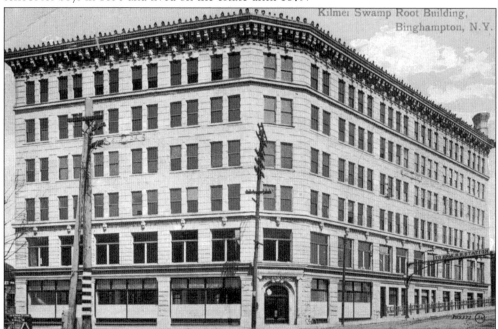

A new Kilmer Swamp Root Factory was constructed in 1903. Eight stories high and covering half a city block, it replaced the Lockwood estate.

A letter written in 1848 describes an experience with a livery stable: "The bar tender charged me twenty two shillings for horse keeping but I ended up paying him but twenty, it could have been lower if I had our trade goods along." The Cafferty Livery Stable was located on Water Street in Binghamton.

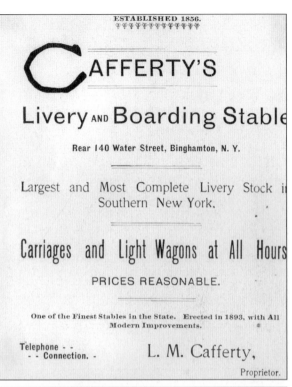

ESTABLISHED 1856.

CAFFERTY'S

Livery AND Boarding Stable

Rear 140 Water Street, Binghamton, N. Y.

Largest and Most Complete Livery Stock in Southern New York.

Carriages and Light Wagons at All Hours

PRICES REASONABLE.

One of the Finest Stables in the State. Erected in 1893, with All Modern Improvements.

Telephone - - - - Connection. -

L. M. Cafferty,

Proprietor.

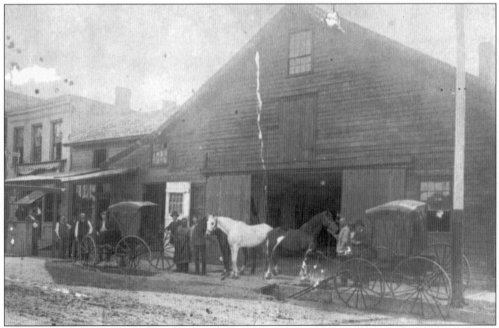

Livery stables and blacksmith shops were a necessity of life before automobiles. In 1867, an advertisement in the newspaper stated: "New Livery Firm purchased the Race & Co. and offer their stock to the public & assure them that none but first class horses & carriages will be kept on hand. Stables are in the rear of the Fireman's Hall. Those wishing stock will please apply at Race's Saloon."

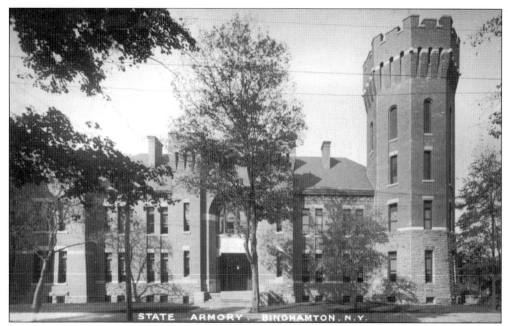

The second New York State Armory was located on Washington Street. It was constructed in 1905 and, in 1946, it housed the New York State Institute of Applied Arts and Sciences, the parent organization of Broome Community College. The image above is the impressive structure intact. The lower photograph shows the armory as it burned to the ground in 1951. A Binghamton fireman was killed fighting the blaze.

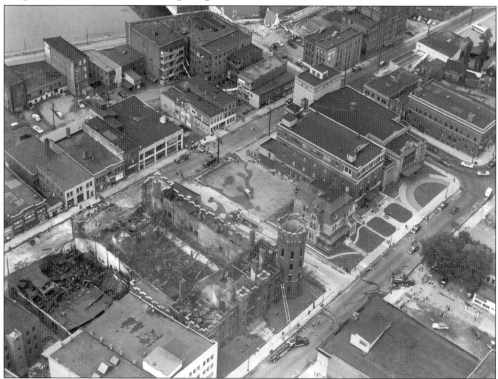

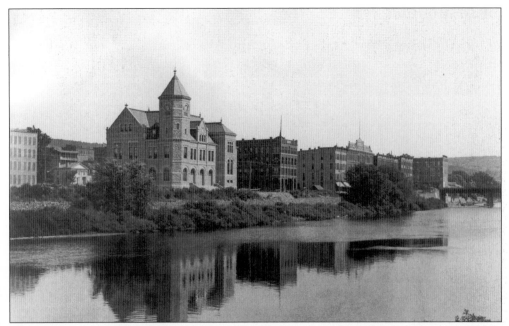

This Binghamton Post Office was built on Wall Street along the Chenango River in 1891. It was severely damaged in the deadly Freeman Overall Factory fire in 1913 but remained in use until 1942, when it was demolished. The structure was not quite as solid as it looked. At the time of the fire, it was discovered that the stone was only a thin facade over a wood frame.

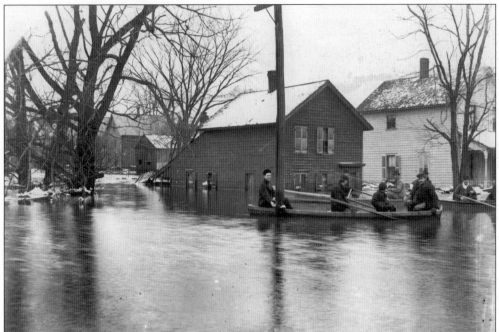

The calm picturesque river in the above image is deceptive. Living in a river basin comes with the peril of floods. In March 1902, the streets of Binghamton and the surrounding area were covered with several feet of water. It was several decades later before adequate floodwalls were constructed.

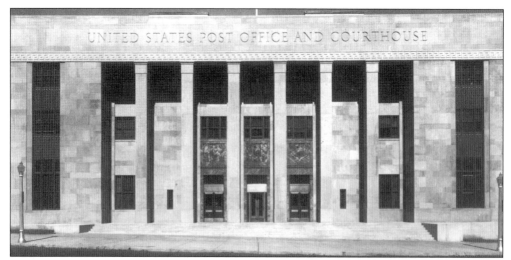

Local postal services were available in 1795, when Binghamton was still known as Chenango Point. Built in 1934 on Henry Street, this building served as both federal building and post office for 29 years.

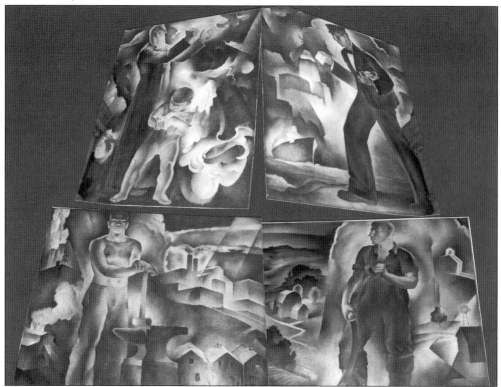

To combat the Great Depression of the 1930s, Pres. Franklin D. Roosevelt created the New Deal programs. The Works Progress Administration aided economic relief to communities. One facet of the program was sponsorship of artists to enhance public buildings with murals. The Binghamton federal building has excellent WPA paintings in the lobby. Great controversy arose about the appropriateness of these paintings because some of the figures were not fully clothed.

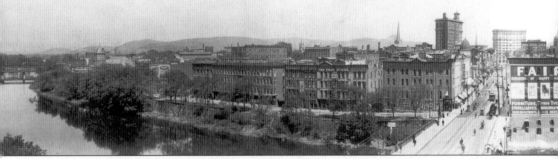

A dominant strength of the early Jewish community was in retailing. Progressing from peddler to significant Binghamton entrepreneurs, proprietors Simon Rosenthal and Harry Rubin created a leading mercantile businesses along the Chenango River in downtown Binghamton: the Fair Store. The concern remained a classic home furnishing company for many decades. The photograph shows the picturesque location and a painted advertisement on the building across the street.

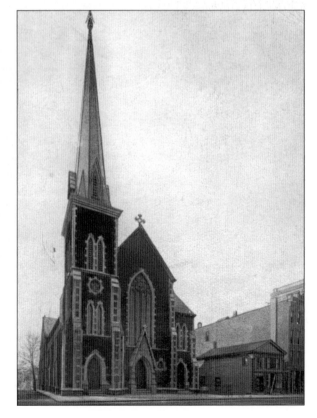

Early Methodists met in a meager building on the corner of Henry and State Streets. Parishioners agreed it was unattractive, with an eight-foot-high pulpit referred to as the "Crow's Nest," and a location near the canal towpath, where "less than holy language" could be heard. It was called the "Methodist Eel Pot," even by members. By 1866, a fitting replacement had been constructed on Court Street, Centenary Methodist Episcopal Church.

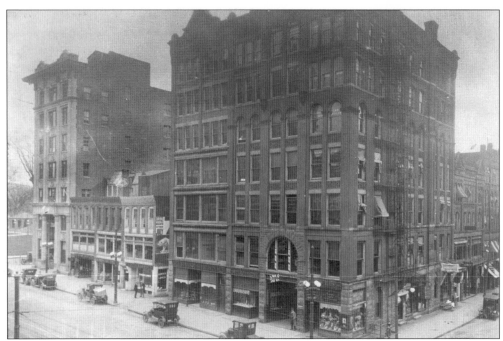

Erastus Ross had a commercial block constructed on Court Street in 1875. He was president of the Merchant's National Bank, which occupied the main floor. In the early part of the 1900s, many small businesses operated on the premises, now known as the O'Neill Building. The Hancock Barber Shop was located on the second floor, and through its large window are visible the past, as well as the other side of the street. The S.S. Kresgee 5 & 10 cent store is clearly visible next to the corner Rexall Store. Prominent on the floor in front of the window is a gentleman's necessity, a spittoon.

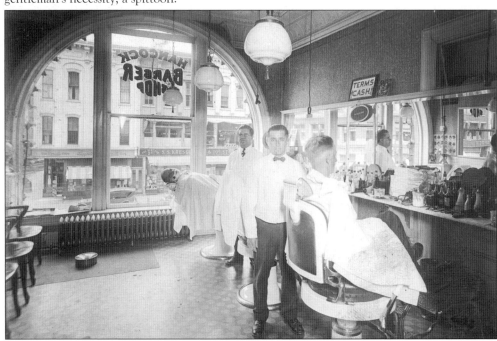

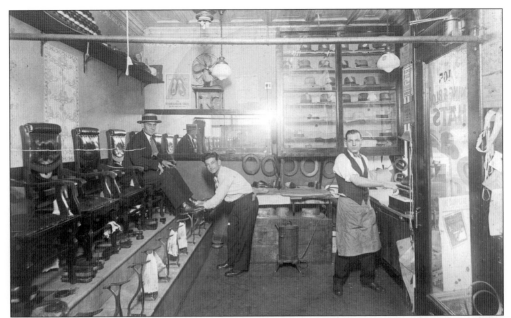

An 1893 Hatter on the first floor of the Ross Block advertised, "Your dome of thought, where convincing arguments and funny new stories are fermented and brewed should be covered with one of our hats!" "Block and stock of the highest quality always available." The shop promised to refurbish a better hat for less money, provided gentlemen's goods, and had a bootblack in residence.

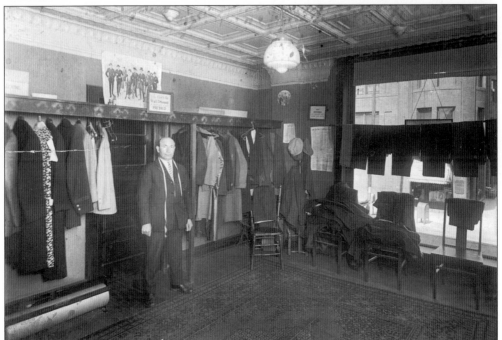

Well-dressed people kept this tailor shop on the second floor in business. The sign behind the proprietor reads "You can't be well dressed unless you're well pressed." The ceilings are tin, and the light fixtures are the same in each store of the complex.

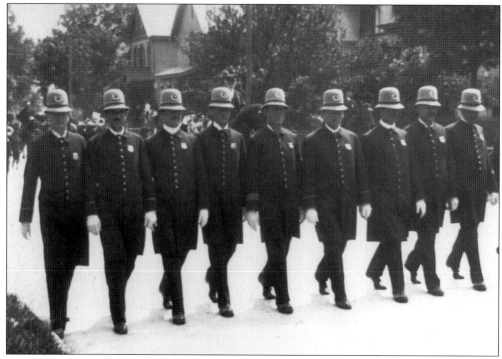

Binghamton had a police constable in 1834, but it was 1881 before the first police commission was created. The law officers on parade in the photograph above wore uniforms resembling the attire of police officials in England.

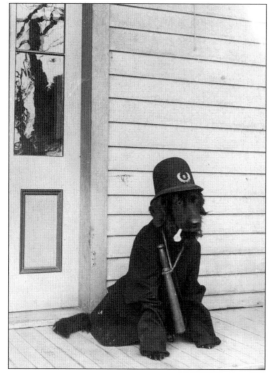

For some unknown reason, this bewildered pooch played policeman *c.* 1900. Clutching a clay pipe in its jaws, the animal is attired in a regulation jacket and helmet and has a billy club. The dog's outfit is quite similar to the uniforms worn by the guardians of the law pictured above.

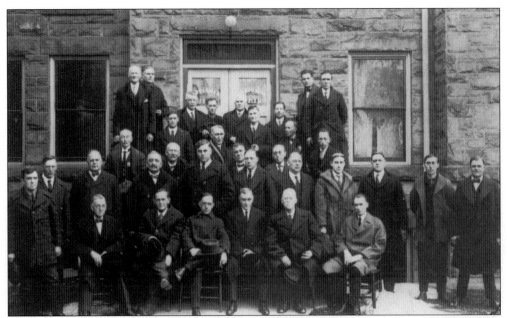

The photograph is of the sheriff and deputies in 1923, when the sheriff's salary was $3,500 a year. The conscientious sheriff in 1933 believed in enforcing the Volstead Act to the moment of repeal. He destroyed a collection of 750 bottles of liquor rather than see the alcohol consumed as a legal beverage, although prohibition was due to end within 24 hours. Prohibition, which lasted from 1919 to 1933, inspired a newspaper article in 1921 quoting a local judge: "I would advise citizens to carry firearms as crime is taking over the streets."

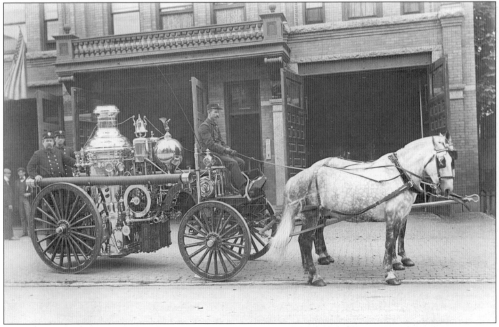

The American LaFrance Company made this fire engine *c.* 1890. It is standing in front of the Central Fire Station. When the machine was retired from active duty, it was displayed in local parades.

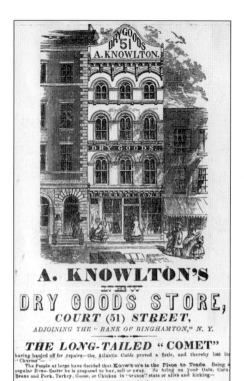

In 1858, 51 Court Street was a dry goods store. Knowlton's stayed in business by bartering, agreeing to "trade for just about anything." It adjoined the old Bank of Binghamton. The photograph above is an 1858 Knowlton's advertisement. Traders had the choice of bringing livestock in a "trance state or alive and kicking." The photograph below is one of the earliest views of the neighboring Bank of Binghamton.

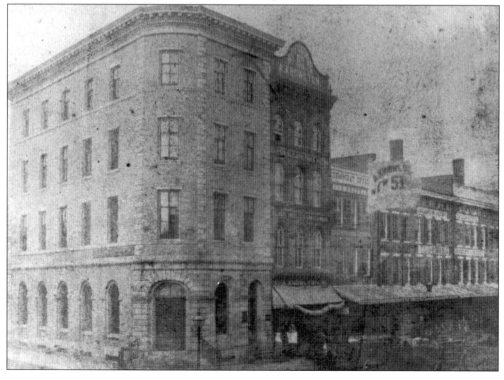

The Bank of Binghamton was chartered in 1852 and has been in business in the same location since 1855. In 1865, it became the City National Bank of Binghamton. In 1923, the old bank building and the Knowlton's block were demolished to make way for a larger and more impressive financial center. The columns of the new entrance are limestone monoliths, over 27 feet tall, weighing 35 tons. The construction photograph was taken in 1923, and the picture of the completed structure, shortly after the new building opened.

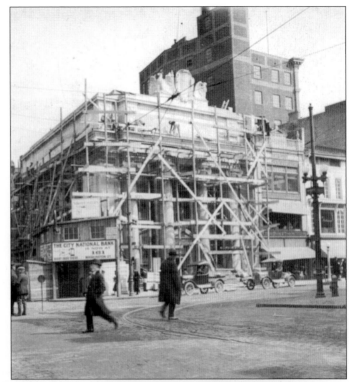

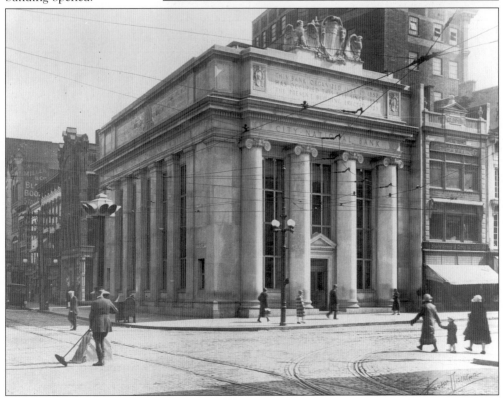

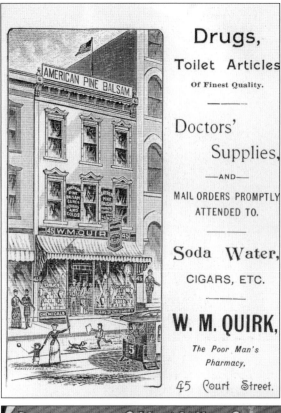

Drugs,

Toilet Articles

Of Finest Quality.

———

Doctors'

Supplies,

—AND—

MAIL ORDERS PROMPTLY
ATTENDED TO.

———

Soda Water,

CIGARS, ETC.

———

W. M. QUIRK,

*The Poor Man's
Pharmacy,*

45 Court Street.

W.M. Quirk operated a drugstore at 45 Court Street and advertised it as the "Poor Man's Pharmacy." This engraving dates from 1894. The store sold cures for colds and coughs and dyspepsia. (Prisons and madhouses were said to be full of dyspepsia sufferers). By 1908, Webster's Cut Rate Drug Store was operating from the same location and guaranteeing to "cure humanity's transgressions of the laws of a healthy stomach" with Blood Wine.

WALTER D. WEBSTER,
Binghamton, N. Y.

A letter penned in 1899 could have been used as a testimonial for Hood's Sarsaparilla, similar to this promotional card from 1884. The gentleman writes: "I have been taking Hood's Sarsaparilla for two days now and I think it is helping me lots. I feel pretty good most of the time and stand my hard work better than you would expect, although I work 13 hours a day."

The Continuous Oil Refining Company was organized in 1867. In 1872, it became the Binghamton Oil Refining Corporation. Petrolina was one of its specialty products. In 1885, the youngest son of the founder of Kattelville, E.C. Kattell, was president of the company. This charming advertisement was a postcard illustrating the great diversity of products produced locally.

IF YOU MUST TAKE MEDICINE
TRY

BINGHAMTON, N. Y.
HOME OF
ATLAS COMPOUND
AND
ATLAS PRINTING CO.
A. C. MAC DONALD, PROP.

Dr. J. MacDonald owned a successful patent medicine business and a printing company beginning in 1900. Atlas Compound was proclaimed to be the greatest medicine on earth, at only 50¢ per box. Consumption of three boxes guaranteed not just relief but cure of any and all afflictions. The Atlas Printing Company of Binghamton produced an almanac that gained great popularity for "predicting phenomenon's." MacDonald claimed to be a prophet and true clairvoyant. He asserted that he was a seventh son of a seventh son and born with a double caul, thus well qualified as a diviner of the future. For many years the company offices were at 53 Washington Street, at the corner of Susquehanna. The building, built in 1817, was the oldest then standing in Binghamton.

DR. MAC DONALD'S ALMANAC FREE
TELLS WHEN TO PLANT AND HARVEST
BY THE MOON

Predictions about Crops, Weather, Sickness, Lucky Days, Future Events, When to Transplant Trim Trees, Set Eggs, Butcher Meats, Travel, Write Letters, Sign Papers, Seek Business, Ask Favors, Borrow Money, Wean Babies, Take Medicine, Perform all kinds Surgical Operations Successfully, Avoid Poverty and Misfortune. A Daily Guide to Speculate, Gain Knowledge, and Make Money. Valuable Information for Show People, Street Venders, Office Workers, Etc.

Post Card

PLACE
ONE CENT
STAMP
HERE

J. MAC DONALD, M.D.

BINGHAMTON,

NEW YORK

Ansco was one of the earliest pioneers in the photography industry, making cameras and photographic supplies in Binghamton starting in 1903. Over the years it changed hands many times. During World War II, when it was controlled by the German corporation AGFA, the U.S. government took possession, maintaining ownership for several years thereafter. Kodak finally decimated this competition by purchasing and dismantling the company in the 1990s.

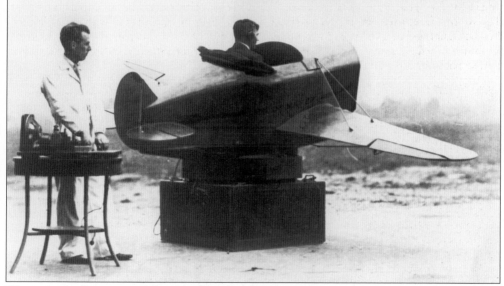

Edwin A. Link progressed from building organs to creating some of the world's first flight simulators. Link Aviation's Blue Box trainer for World War II pilots is shown in this photograph. It was patented as Pilot Maker in 1929. An inventor of incredible vision, Link made simulators for space and earthbound and undersea vehicles. The company was a major employer in the area for decades.

ALBANY
City Dental
Association

At Binghamton, N.Y., No. 47 Court St., over First National Bank,

Are making a Set of Teeth for $5.50. Best Set, $8.00.

☞ These are the best that can be made by any Dentist, and are made of Best Material.

Teeth Cleaned	$.50
Teeth Extracted	.25
Gas	.50
Teeth Filled with Amalgam	.25
Teeth Filled with Silver	.75
Teeth Filled with Gold	$1.00 and upwards.

Gold Fillings a Specialty. All work Warranted in every particular.

We are permanently located in Binghamton.

Take a look at the prices that the Albany Dental Association was charging in 1882. If you think it was a bargain, look again at the instruments used to provide the service. This notice appeared in a leaflet promoting the industrial and commercial benefits of living in Binghamton.

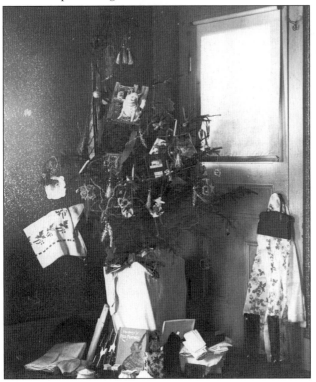

As the year ended in another era, profound changes are evident in holiday celebrations. Soon after this image was imprinted on a glass negative, the world moved from simplicity to commercialism. This Christmas tree will forever hold its needles and memories of a lost way of life. Decorated with homemade ornaments and candles, the gifts were practical and few. This photograph was taken in the early 20th century.

Three

EAT, DRINK,
AND BE MERRY

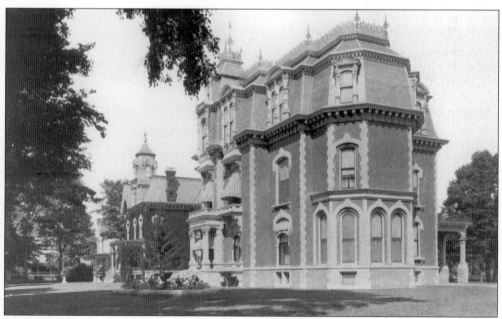

The Phelps Mansion, built in 1870, was one of the most costly residences ever constructed in the city. In 1904, the home was purchased by the Monday Afternoon Club, a women's organization dedicated to the cultural advancement of its members and community philanthropy. In a small lapse of tolerance, in 1915, two women were barred from membership due to evidence of "pro-suffragist tendencies." By 1917, Binghamton overwhelmingly voted for woman's suffrage.

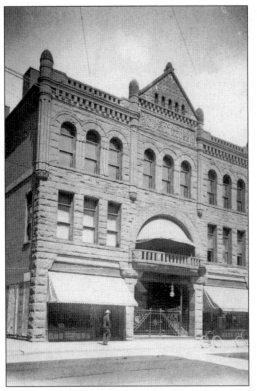

The Stone Opera House, constructed in 1892 on Chenango Street, was called an opera house in an attempt to dignify a public performing hall. A letter written in 1899 describes a visit to the establishment. "I went to a Cake Walk performance tonight in the Opera House and I never saw anything so foolish in all my life. I was disgusted and tired out from exasperation when I got back home." The cakewalk was a high-stepping and kicking dance done to spirited music, mimicking the stiff manners of proper society. In pre-Civil War days, a cake was offered to slaves for the best performance of the dance. Thus, the term "that takes the cake" became part of American slang. By the 1890s, cakewalk dancing swept the nation. The photographs are of the exterior and interior of the Opera House.

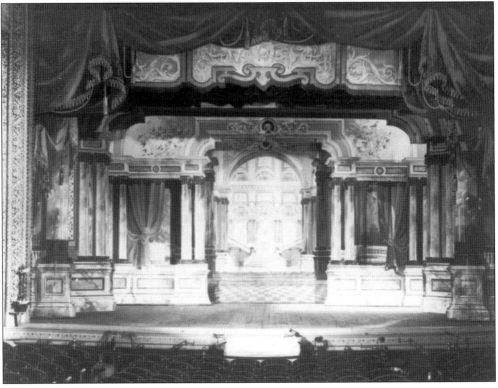

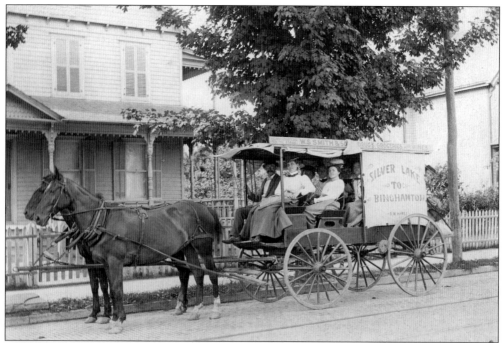

In the late 1890s, leisure time was taken very seriously. A special stagecoach ran to Silver Lake camping and picnic grounds from Binghamton. Tickets were available through the local grocery store. Note the brick streets where the modern stage awaits a full compliment of travelers.

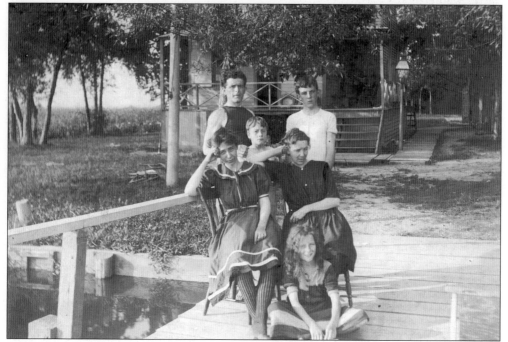

Once arriving at the campgrounds, the vacation hilarity begins with swimming, as indicated by the obvious joy on the swimmers faces.

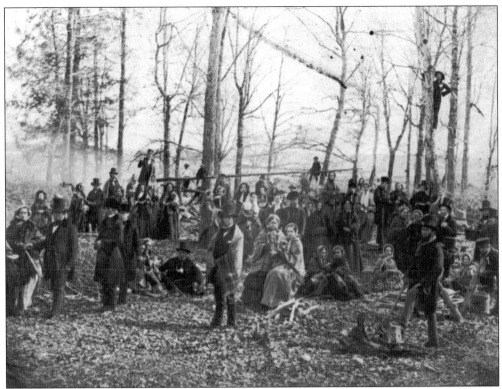

A sap celebration was a rite of spring in long-ago Binghamton. This photograph from the 1870s shows a gathering to tap maple trees for syrup. Although the sap was rising, it is obvious that the temperature this day was low.

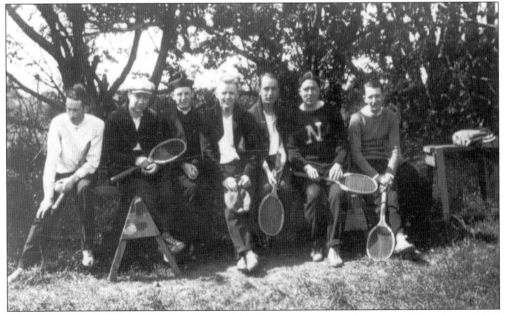

Pastor and players pose on a sunny day in 1929 . . . court optional . . . or perhaps it was field tennis. In any event, it was another sport that occupied the time of many local residents.

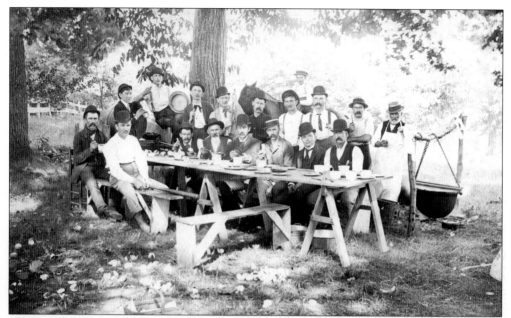

"Men on a Mountain" are enjoying a clambake in a woodland setting in 1890. Known as the Mount Prospect Jolly Club, they were probably employees of the West & Kress Brewery. Clamshells can still be found among the stones on the hillside, attesting to the great number of parties held on the towering slopes.

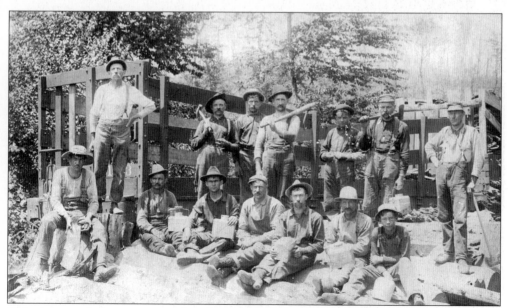

This photograph shows a group of workers about 1900 eating lunch from dinner pails, far from city conveniences.

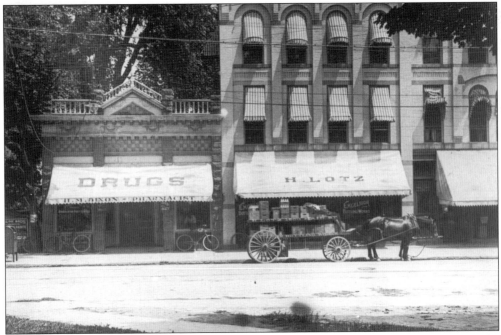

Harry M. Dixon owned a pharmacy in the early 1900s located at 162 Main Street. It was the first drugstore in the city of Binghamton to install a soda fountain. The exterior photograph is from 1903, and the interior of the same shop was taken in 1906. The Excelsior Bottling Works, owned by H. Lotz, was located next door to Dixon's. A weary delivery system is parked in front of the establishment.

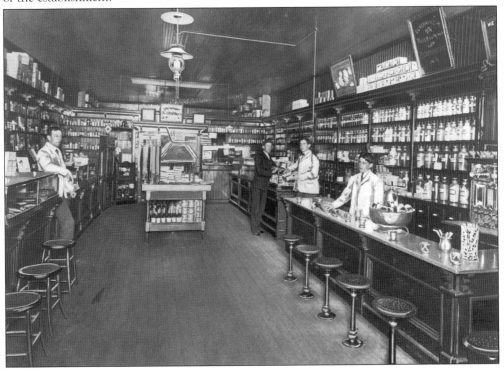

In 1902, White City was advertised as "Binghamton's Fairyland" but was located in the village of Lestershire on Riverside Drive. It claimed to have "High Class Amusements," but the entertainment attracted an element of society so disreputable that a stone jail was built on site to house "drunkards and those of moral depravity." The Rev. John Davis would often drop to his knees and pray in front of the park entrance, asking for deliverance of the property into his hands for "Godly" pursuits. By 1910, his request was granted: White City went bankrupt and was purchased by Davis and his followers. Bible School Park was then established and today is the Practical Bible Training School. Pictured are a 1908 advertisement for White City and a card notifying area residents of evangelist meetings, showing a photograph of Davis.

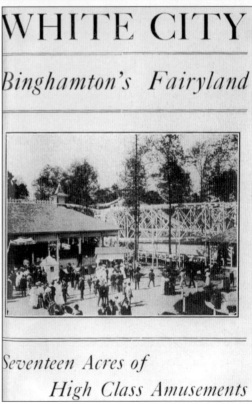

WHITE CITY

Binghamton's Fairyland

Seventeen Acres of
High Class Amusements

This dainty young lady was Miss Binghamton Teenager of 1905. She is wearing an ensemble guaranteed to create envy among peers—only slightly different from prom gowns of the 1990s.

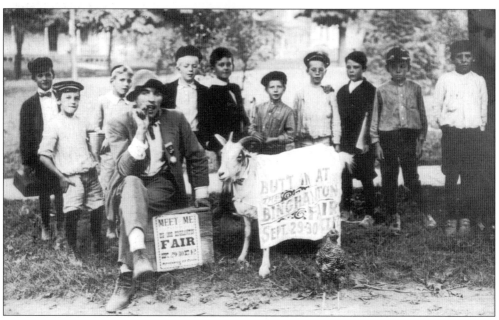

The first day of the Binghamton Fair was designated Children's Day. The youngsters could attend for a reduced admission of 10¢. A goat and a chicken were in attendance at this meeting, with the message "Butt in at the Binghamton Fair."

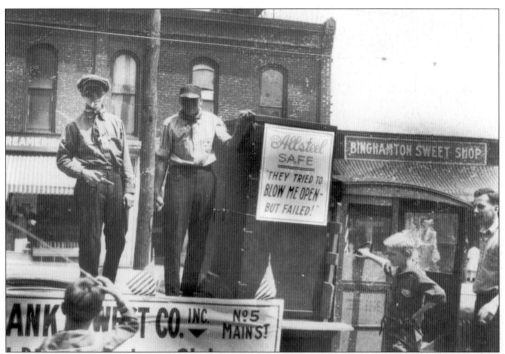

Frank West Company created a "safe cracking" float for a parade that rolled through the streets of Binghamton. The photograph above was taken at a momentary stop in front of the Binghamton Sweet Shop. The picture below shows the interior of a typical sweetshop, with showcases of penny candy and fresh-baked bread, cakes, and pies.

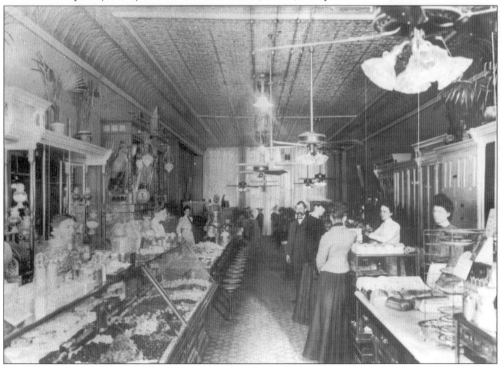

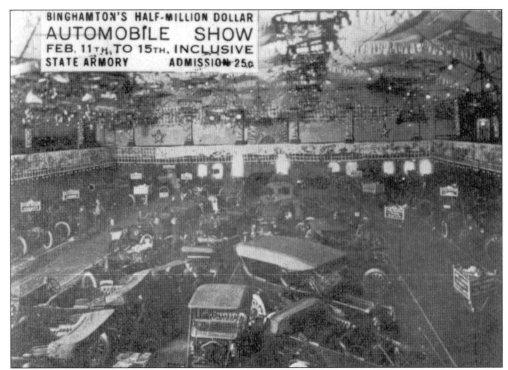

In 1912, Binghamton held an automobile show featuring half a million dollars' worth of autos and accessories, "5000 electric lights, electric fountains and oriental decorations." All were on display inside the New York State Armory building.

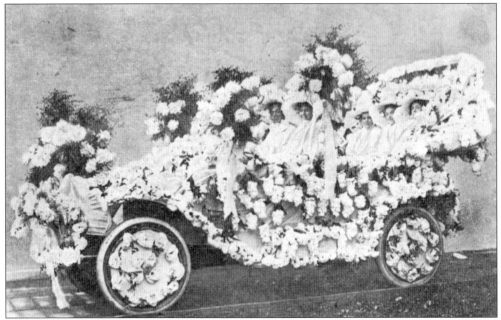

This flower-draped car, owned by Dr. C.S. Decker, won first prize in the Automobile Parade of 1912. The event was sponsored by the local Auto Club. The postcard message advises members, "you too can decorate just as easily and win just as easily as Dr. Decker."

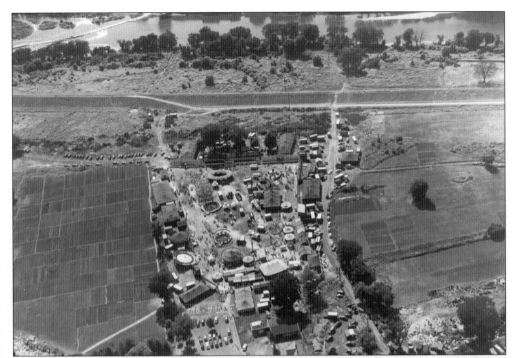

The Stow Flats Fairground opened in 1892, located between the river and State Street approximately where the Binghamton Plaza is today. This aerial view was taken in 1935. Much of the nearby land was still used for farming. In later years it became a dump site. A good example of land evolution, this tract went from fairgrounds to dump to plaza.

Imagine 1919 and you might think of a convertible Studebaker ready for a drive in front of a typical Binghamton residence. The men are sporting straw boaters, complementing the "merry widow" chapeau of the female passenger.

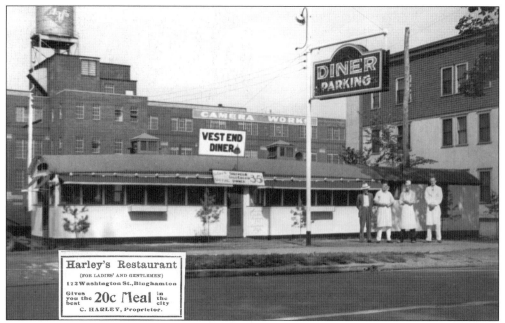

Eating out before the days of fast food offered many options. The insert advertisement above is from 1900, offering 20¢ meals. The restaurant pictured was located on Main Street c. 1930, when the price of a meal had risen to 35¢.

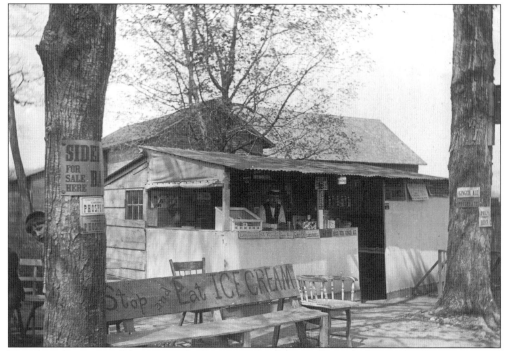

To take advantage of the new vehicle touring trade, simple roadside stands opened in front yards along motorways. This stand c. 1920s sold cherry phosphate, 5¢ cigars, sarsaparilla, and ice cream—the beginning of the fast-food era. The photographer caught a cute patron peaking from behind the tree.

"The Riverside Rag" was a song written by Binghamton patriot Charles Cohen in the very early 1900s. He was impressed with Riverside Drive and composed music to celebrate the Riverside Amusement Park. From his home on Haendel Street he taught music, scheduled organ and piano repairs, and played at events. By 1925, he was also playing as a musician at the Star theater.

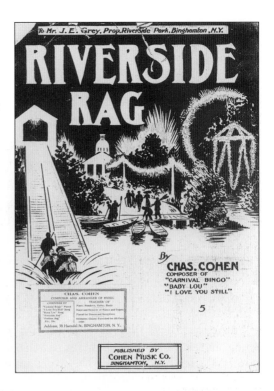

Binghamton resident George Kelly was nationally known as the "Champion Leaper" in 1866. His ability to jump from a springboard and soar over 12 horses was honed by practice in the Weed Tannery on Susquehanna Street. Performing with major circuses of the day led him to the championship leaping medal in London in 1863.

"A loaf of bread, a jug of wine, and thou"? Not quite. The situation is closer to "beer in a pail, a pipe, and a pal." The men are strolling along a part of Oak Street once known as Pig Alley.

On the back of this advertisement for Merchant's Gargling Oil "for man and beast" is a promotion for a beer hall located at 53 Washington Street. It was in operation before 1900. The liniment, good 5¢ cigars, and local beer were available at the business. The building was one of the oldest in the city.

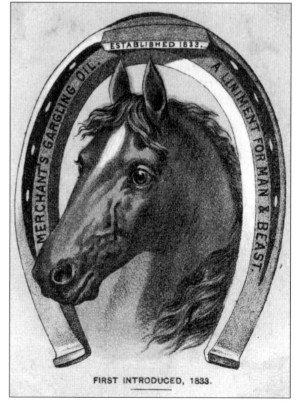

ESTABLISHED 1833.

MERCHANT'S GARGLING OIL.

A LINIMENT FOR MAN & BEAST.

FIRST INTRODUCED, 1833.

Joseph Laurer opened a brewery in 1881 on Laurel Avenue. The company was capable of producing 20,000 barrels of lager beer annually. Parts of the original brewery are still standing and now house the Bates Troy Laundry.

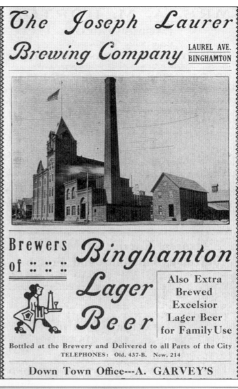

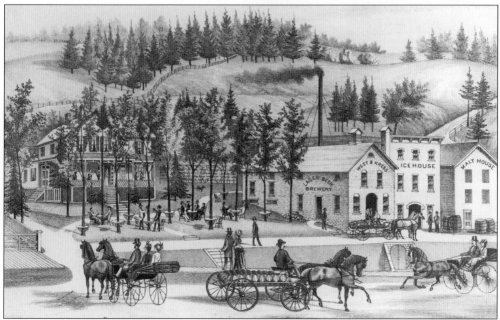

Halfway up Mount Prospect was a small brewery run by Lewis West in 1866. The West & Kress Brewery venture did not prove profitable and was only in business for a short time. The West family went on to become prominent in several other local enterprises. The engraving is from a 1866 Atlas of Binghamton. This hillside location is now part of Route 17, locally known as "Kamakaze Curve."

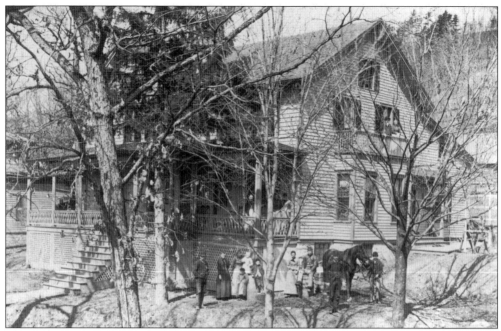

The West family homestead was located on Prospect Mountain near the West & Kress Brewery. The large family gathered in the front yard for parties and entertainment. One can only guess as to what production required the men of the family to dress in bonnets and gowns. Both photographs were taken at the West home in the 1870s.

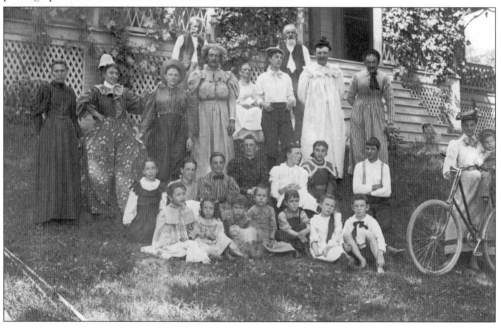

Members of the West family had a good view of the valley from their porch and hammock. When they grew adventuresome, the whole clan packed food and tents and went for an outing along the Susquehanna River, taking both bicycle and horse. The date on the photographs is 1897.

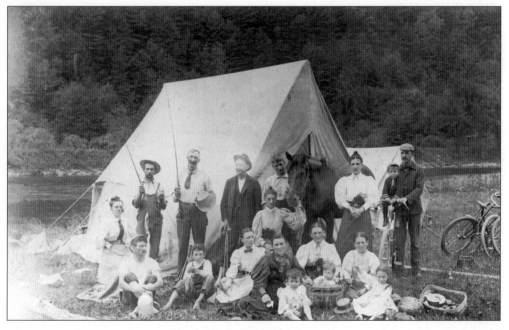

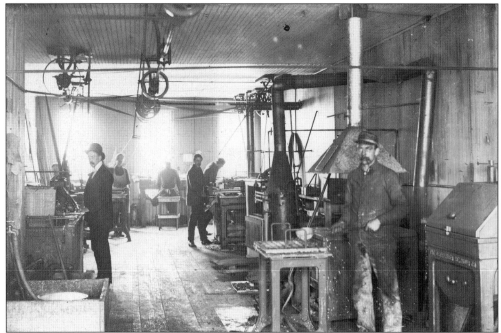

Frank A. West was successful in the printing and bookbinding trades. Born in 1878, he founded the West Printing and Binding Company in 1901. The above view *c.* 1905 is of his type foundry. The photograph below, of the West Book Binding operations, dates from the same era. The names of the employees are indicated at the top. Note the modern gas lighting on the brick wall near the clock.

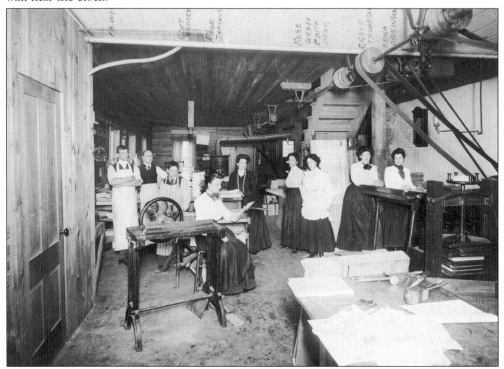

Baseball is the American national pastime, and little boys seem to be born wearing the uniform of a ball player, as in this photograph of a child in the late 1800s.

Football derived from several ancient games, and a type of football association was organized in New England during the Colonial period. Local players have carried on the tradition of battering body and ball. This photograph was made in the early 1900s on a glass negative.

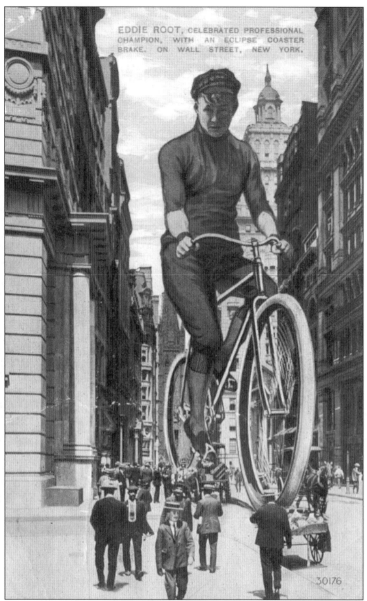

EDDIE ROOT, CELEBRATED PROFESSIONAL CHAMPION, WITH AN ECLIPSE COASTER BRAKE, ON WALL STREET, NEW YORK.

A bike craze swept the country beginning in the late 1800s. At least two pages of the weekly seven-page newspaper were devoted to cycling news.

1897 – "Cycling slang of the day indicates a proper term to apply to the man or woman who thinks they can ride—but can't—is best expressed by saying that every season brings forth a plentiful crop of GLINKS."

1897 – "Beware! A law stating that it is now the front rider on a tandem wheel who is responsible in case of accident has been enacted in Germany and the USA may be next!"

1898 – "It is eminently proper to ride a bicycle in a funeral procession when the corpse is that of a "SCORCHER." (A scorcher was a very good bicycle rider.)

The picture is a postcard sent to many hundreds of Binghamton residents encouraging the purchase of the latest bicycles in the stock of a local retailer. Eddie Root was a champion bicycle racer and sports hero in 1911.

An 1899 letter from a Binghamton man reads as follows: "I got me a new black bike suit last week and it fits me very nicely especially the pant legs. They are tighter than skin for I can sit down in my skin and I can't in the pants. They are just two inches around the bottom and I can't get the pants on without trying to shrink my feet by washing them.

An 1894 news article reads: "It makes a wheel woman wince these breezy days to think of riding across Court Street bridge. She suddenly finds herself at the mercy of a hustling wind, and one pair of hands can't at the same moment be gripping handle-bars, clutching a hat wishing to go excursioning on its own, and holding down a skirt wanting to resolve itself into a good sized balloon." Later in 1894, some very daring women tried to solve the problem of skirts and bikes. "There was a parade through downtown Binghamton of women on bikes wearing controversial garb . . . divided skirts!"

In leisure moments local residents took advantage of the chance to immortalize their likeness. Both photographs were made on glass negatives *c.* 1899. Although no names were attached, the images preserve priceless moments in time, even for the family pets.

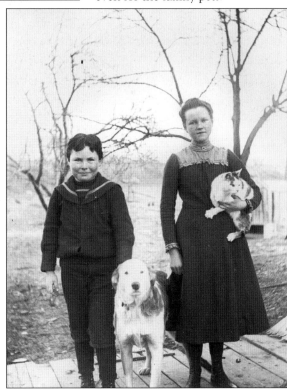

Could this be a version of the *City Mouse and the Country Mouse*? The city children are riding their bicycles in a fenced garden on a stone path. These trikes have full bench seats and solid rubber tires. The home is in Sparrowville, a large estate on Main Street in Binghamton, owned by their father Frank White. The garden also included a greenhouse, a gazebo, and a nanny.

In the country the bicycles are similar, the yard is dust instead of flowers, but the smiles are the same. The child standing to the right is wearing a Civil War cap, and in spite of the dress is probably a little boy.

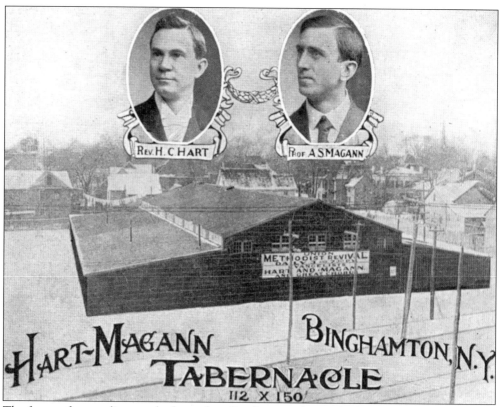

The fervor of evangelism reached a peak in Binghamton during the late 1800s and early 1900s. Great evangelistic campaigns were well attended and entertaining. The meetings usually included inspiring revival speakers, animated music, and dramatic testimonials. The Hart-Magann campaign sent out the above postcards announcing its arrival at Tabernacle Hall.

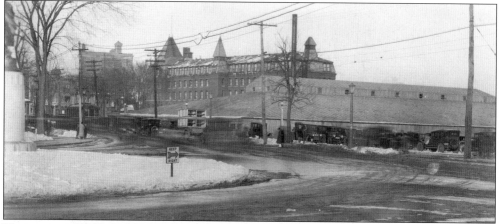

The renowned Billy Sunday spoke often at the hall built for his use in 1925. The building was located near Memorial Circle. Standing-room-only revival meetings were conducted for many years at this site. The Endicott Johnson Shoe Company purchased the building c. 1933, put brick walls up around the existing structure, and renamed it the George F. Johnson Tabernacle Factory. The top photograph shows the building as a revival site, and this image as transformed into a shoe factory.

114

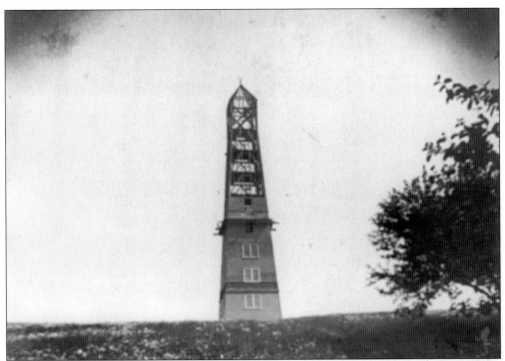

The Ely tower was built in 1907 on Mount Prospect in a park that S. Mills Ely presented to the city. The imposing spire was constructed as a memorial to the Mills revivals held in 1894. It was assembled with recycled lumber from a large temporary tabernacle that seated nearly 4,000 people. Several years later a violent windstorm demolished the tower and it was never rebuilt. The photographs show the tower as it was being built and again shortly after its destruction.

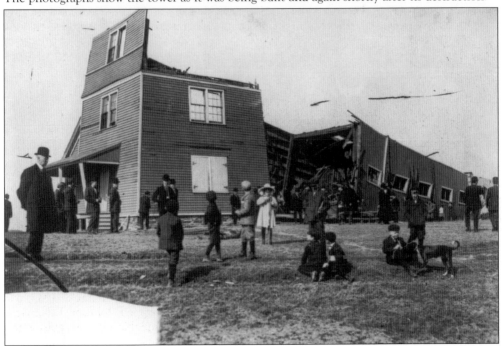

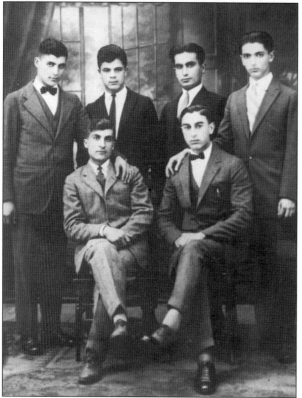

Immigrants from all over the world came to the Triple Cities (Biinghamton, Johnson City, and Endicott) because of the many opportunities for work and the congenial social atmosphere. The men in the photograph to the left came from Lebanon c. 1910. The performance, with people in their native garb, is Slovakian. The entrepreneurial attitude of immigrants from dozens of nationalities led to a strong local workforce. The mosaic of cultures has created an interesting and diverse community. Residents of the First Ward believe the above photograph was taken in the original SOKOL Hall, which is now the Senior Center on Clinton Street.

Promoting a belief in hate, fear, and evil, the Ku Klux Klan gained a foothold in this area in the 1920s. Binghamton became the state headquarters for the Klan, with offices in a building on the corner of Henry and Wall Streets. Cross burnings, parades of masked members, and outdoor meetings of white robed bigots were a frequent sight. Some of the KKK gatherings were held at the Stow Flats fairground. Merchants sympathetic to the Klan put secret codes in their advertisements indicating belief in the cause. Eventually, Binghamtonians rebelled, and the Klan presence in the community faded. The photographs show an authentic uniform, a professionally produced record, and a poster that were all found in local homes after the owners had passed away.

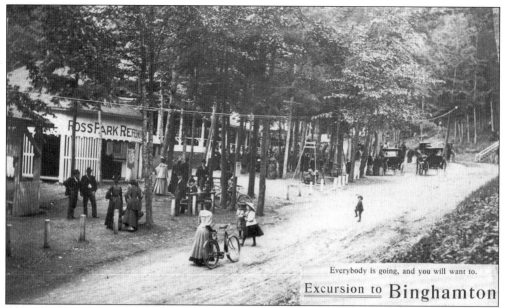

Everybody is going, and you will want to.

Excursion to **Binghamton**

Ross Park, 90 acres on Binghamton's south side, was given to the city by Erastus Ross in 1875. Daylong excursions were encouraged so that the unique features of natural beauty, the kinetoscope, phonograph, and "refined stage acts" could be enjoyed. At the time this whole side of town was called Rossville. Today, the park includes an antique carousel and one of the oldest zoos in the nation.

In the year 1790, the local government fixed a bounty of 20 shillings for a grown wolf and 10 shillings for animals under one year old. In 1822, the bounty increased to $10 per hide. Currently, a unique exhibit at Ross Park Zoo is a wolf den in a natural setting. In the journey of mankind to civilization, attitudes towards this animal have changed from persecution to preservation.

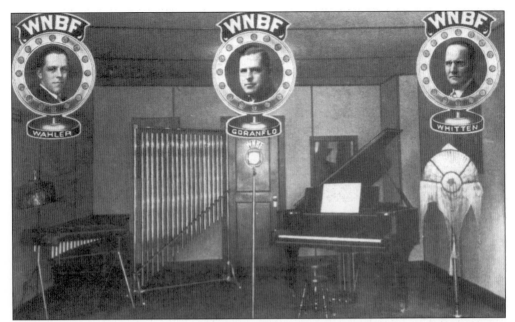

Binghamton's radio pioneer was an eight year old boy who devised his own crystal installation in 1906. By 1924 there were still only two thousand radios in the city. This photograph is an early advertisement for local station WNBF.

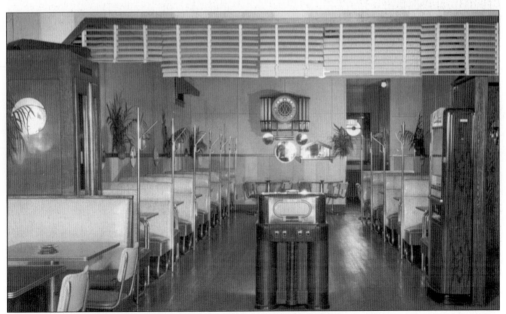

From the late 1920s through the 1940s, the radio replaced the music room in home and business establishments. The photograph from the 1930s shows a local restaurant with an art deco interior. The floor-model radio holds a prominent place in the decor.

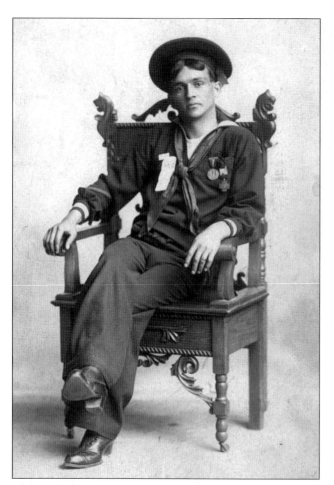

World War I was called the "war to end all wars." The charming photograph is of a young man serving in the navy in 1916, before the reality of death and destruction became part of his life.

In the 1940s, it was again necessary to fight a "final war," World War II. The passions of yet another generation were entwined with war, patriotism, and death. Every ray of humor was a welcome relief. This V-MAIL was sent long before "politically correct" attitudes became invasive.

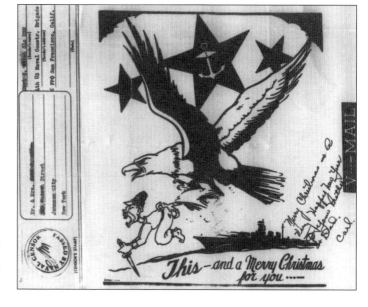

Rationing of goods and quantities was a vital part of the U.S. war effort during World War II. A variety of ration coupons surround the pictures. Ladies' stockings were unavailable during the war, and leg makeup filled the need. Just before reporting for duty in the U.S. Army, Len Robenolt and wife, Evelyn, enjoyed a picnic in a breezy meadow on Mill Hill, offering opportunity to check the leg makeup application.

As World War II ended, the cold war began with many children hiding under schoolroom desks for the periodic air raid drill, in the naive belief that it was protection against an atomic bomb. Civil defense was part of the American culture, and many homes in the area still have basement bunkers reflecting the fear of the "Red Tide of Communism." The concrete shelters were partly financed by tax rebates.

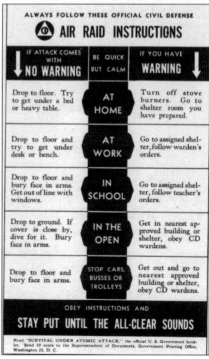

ALWAYS FOLLOW THESE OFFICIAL CIVIL DEFENSE
AIR RAID INSTRUCTIONS

IF ATTACK COMES WITH ↓ NO WARNING	BE QUICK BUT CALM	IF YOU HAVE WARNING ↓
Drop to floor. Try to get under a bed or heavy table.	AT HOME	Turn off stove burners. Go to shelter room you have prepared.
Drop to floor and try to get under desk or bench.	AT WORK	Go to assigned shelter, follow warden's orders.
Drop to floor and bury face in arms. Get out of line with windows.	IN SCHOOL	Go to assigned shelter, follow teacher's orders.
Drop to ground. If cover is close by, dive for it. Bury face in arms.	IN THE OPEN	Get in nearest approved building or shelter, obey CD wardens.
Drop to floor and bury face in arms.	STOP CARS, BUSSES OR TROLLEYS	Get out and go to nearest approved building or shelter, obey CD wardens.

OBEY INSTRUCTIONS AND
STAY PUT UNTIL THE ALL-CLEAR SOUNDS"

Read "SURVIVAL UNDER ATOMIC ATTACK," the official U. S. Government booklet. Send 10 cents to the Superintendent of Documents, Government Printing Office, Washington 25, D. C.

The Front Street Drive In Theater was an icon of the 1950s. Parents packed pajama-clad kids, popcorn, and pillows into the family vehicle for an evening of family movies. The few minutes before it became dark enough for the films to start were filled with anticipation—and the proper adjustment of the bulky metal speaker hooked to the driver's window.

The 1950s also changed home entertainment. The radio began to take a back seat to the newest method of communication, television. The photograph is of a typical living room TV set with a genuine imitation brass western horse sculpture, including a clock and a small light. This model TV cabinet included a built in record player. The plastic-covered hassock opens for storage of the latest albums and magazines.

The decade of the 1950s was still a time of innocence: crew cuts were fashionable, and working hard to get ahead in life was expected. Beginning at an early age, young people took on the responsibility of delivering the *Binghamton Press,* a job that helped mold a character of dependability for future life.

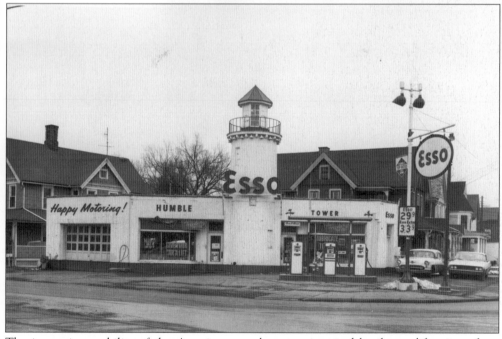

The increasing mobility of the American people was epitomized by the proliferation of gas stations, automobiles with fins, cruising, and car radios playing rock 'n roll. The distinctive lighthouse design of this Esso gas station has been preserved. It is now the Woodfern Plant and Florist Shop, on Chenango Street.

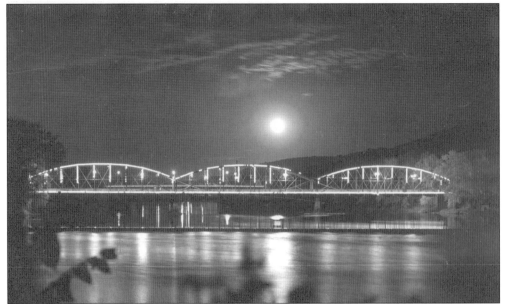

South Washington Street Bridge was built in 1886, replacing a wooden span that charged a toll. It is one of the last iron parabolic arch bridges in New York. When the historic structure became unsafe for auto traffic, it was refitted for foot traffic only and preserved as a historic landmark. It is outlined with lights year-round, bridging the past with the future. The dramatic photograph is by Ed Aswad.

There are six vintage Herschell carousels located in parks throughout the Triple Cities due to the generosity of the George F. Johnson family. The merry-go-rounds have been placed on the National Register of Historic Places and are a unique part of local history, as well as a modern-day tourist attraction.

A balloon or two flew over Broome County in 1905 at the Binghamton Fair at Stow Flats. Today, hundreds of brilliant-colored airships are launched at Ostiningo Park each summer as part of the annual Speedie Festival and Balloon Rally. Speedies are a regional food delicacy of marinated meat grilled on a skewer. The recent photograph was taken from a helicopter by Ed Aswad.

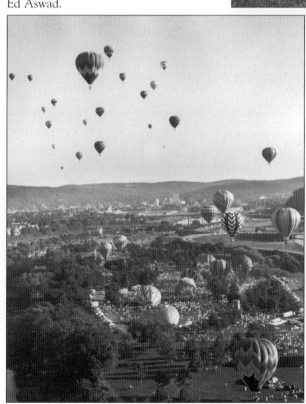

Preservation and promotion came together in 1990 when Binghamton locations were selected to be used as settings in the major motion picture *Libestraum*. The cast iron building designed by Isaac Perry on the corner of Court and Chenango Streets in the 1800s is one of the last structures of this kind in the country. It was a focal point in the movie. Streets were closed to make way for cameras, lighting, actors, and crews of set designers. The Perry Block was transformed into an aging derelict and then back to Victorian elegance. The movie premiered at an aging theater on Clinton Street in 1991 but did not gain fame here or anywhere else. Unfortunately, the production was more exciting than the final product. Photographer Ed Aswad documented the motion picture production and these photos are part of his collection.

In 1932, a funeral procession wound solemnly down Court Street. The deceased was a mode of transportation. The procession was led by a horse-drawn trolley car followed by an electric streetcar, both draped in heavy black crepe. They rolled along to a dirge, followed by a gasoline-operated bus that had killed off its predecessors.

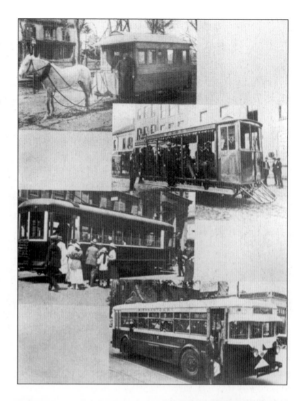

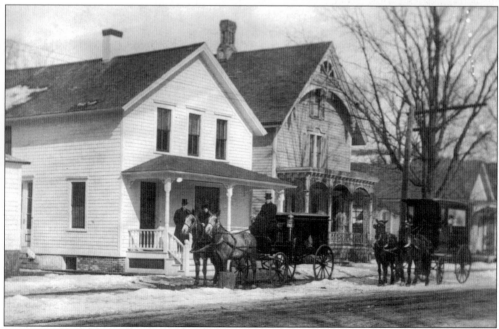

Horse-drawn hearses from an earlier century await business adorned in the classic trappings of death. Poetry in the past extended to the grave through obituaries: "For those who have left the stage of life, made the transition and awoke on the other side, gone over to the majority and paid their debt to nature and now live in a more blissful clime, we extend our respects."

BIBLIOGRAPHY

Binghamton Chamber of Commerce. *The Valley of Opportunity*. Binghamton, New York: Charles W. Baldwin, 1920.

Binghamton Illustrated. Binghamton, New York: H.R. Page & Company, 1890.

Binghamton Past and Present: Its Commerce, Trade and Industries. Binghamton, New York: Evening Herald Company, 1894.

Bothwell, Lawrence. *Broome County Heritage: An Illustrated History*. Woodland Hills, California: Windsor Publications, 1983.

Combination Atlas Map of Broome County New York. Philadelphia: Everts, Ensign and Everts, 1876.

Hinman, Marjory B. *Courthouse Square: A Social History*. Endicott, New York, 1984.

Lawler, William S., ed. *Binghamton, Its Settlement, Growth and Development*. n.p: Century Memorial Publishing Company, 1900.

Putnam, Dr. Frederick, comp. *A Documentary History of Broome County*, 126 volumes. Manuscript Collection of the Broome County Public Library History Center.

Seward, William Foote, ed. *Binghamton and Broome County New York: A History*, 3 volumes. New York: Lewis Historical Publishing Company, 1924.

Smith, Gerald R. *The Valley of Opportunity, 1988*. The Donning Company Publishers & the Broome County Historical Society.

Smith, H.P., ed. *History of Broome County*. Syracuse, New York: D. Mason and Company, 1885.

Sussman, Lance J. *Beyond the Catskills, Jewish Life in Binghamton, NY, 1850 to 1975*. State University of New York at Binghamton, 1989.